GÉRICAULT

and his

WORK

GÉRICAULT
and his
WORK

by
KLAUS BERGER

Hacker Art Books New York 1978

TRANSLATED BY WINSLOW AMES

First published 1955, Lawrence, Kansas.
Reissued 1978 by Hacker Art Books.

Library of Congress Catalogue Card Number 76-39815.
International Standard Book Number 0-87817-198-3.

Printed in the United States of America.

Translator's Note

This book is a rather free translation from the original German text published by Anton Schroll & Co. in Vienna in 1953. I have had the advantage of frequent consultation with the author, and of editorial help from the Editor of the University of Kansas Press. The author has approved numerous transfers of epithet and other devices, including a somewhat more colloquial style than is usual in German, which are intended to make the English text as readable as the original. He has also brought certain ownership-credits and other catalogue information up to date, particularly in the notes near the end of the book.

CONTENTS

GÉRICAULT
and his
WORK

I. Introduction

Only three of Géricault's pictures were exhibited during his lifetime. One of them, the *Raft of the Medusa,* became, without his complicity, the center of a public scandal which had nothing to do with art. Enthusiasm for the picture, or really only for the moral effect of its subject, was presumably a touchstone of liberalism, of opposition to the Restoration monarchy; while lack of enthusiasm was taken as a wish to make no drastic criticism of conditions, as a sign of conservative thought.

After the *Medusa,* Géricault showed nothing more, and he died five years later. That work alone made his name popular; thus it is that Géricault has long remained "at once famous and unknown," and so achieved what Degas in a cynical moment asked for his own artistic reputation.

The end of Géricault's short life and activity coincided with the Salon of 1824, the triumph of Romantic painting in France. Nothing was easier than to pull the "rebel" posthumously into the circle of the Romantics and to see him as a sort of forerunner of Delacroix. Ordinarily it does not matter very much whether a label is hung on an artist without his knowledge, especially when the label is involved with so vague and unexplained an idea as that of the romantic in painting. But in the case of Géricault it mattered a great deal, and in the worst way. Fanciful stories, true or false, rose up about his name to compensate for the inaccessibility or the unknown character of his works. Suggestions of eccentricity load the literature, from the way he wore his hair and the habits of his Negro servant to the fact that the prostitutes' street in Rouen was given his name. Do not earnest critics assure us that he never represented a woman or a child, and that he disdained the art of antiquity? In the first forty years after his death there arose a Géricault legend, so impenetrable that another three-quarters of a century of critical research has not yet been able to prune it clear.

In 1867 Charles Clément published, first in the *Gazette des Beaux-Arts* and then in book form, his basic study of the artist, with the catalogue of all the works known to him, which reached the imposing number of 478. He set himself the task of giving "the greatest artist of his time" the honor and justice he deserved; it is only fair to say that it would be impossible, without Clément, to trace many of the paintings, drawings, and lithographs now scattered to the corners of the earth; Géricault research would hardly have come into existence.

Since then a long series of connoisseurs has been occupied with the various

aspects of Géricault's art, and has revealed in him a monumental artist of comprehensive imagination, who held his own against the Neoclassic, Romantic, and Realistic movements of the 19th century. His works have been shown in numerous exhibitions, especially since the centenary of his death in 1924; museums have acquired them, and the three known works of his time have been multiplied by hundreds.

The following is a new view, in text and illustrations, of all this abundance. The world that Géricault made has come late into our ken, so that it still preserves a certain freshness, and happily has not yet been entirely docketed. Full of lively contradictions, his art may be just the one to cast a clear light on his contradictory period. It is an epoch of new questions to which he can give bold answers drawn from the experience of wide horizons; an epoch which combines tradition and revolution in so individual a way that, even with the perspective of our generation, we find its actuality still glowing.

There are three aspects under which an artist such as Géricault can be studied. First there are the facts of his life, which forward or retard his artistic activity; here we must separate "truth" from "poetry" in the publications that have accumulated over 125 years, for decisive new documents are no longer to be found. Second, the motifs that the artist as a child of his time has taken up; and here it is interesting to make acquaintance with his ideas, in which a good deal of cultural history is involved. Except for Goya, no artist reflects so drastically the change from the old to the modern outlook on the world, or the revolution of social sensitivity so plainly, as the author of the *Slave Trade* (pl. 87). Third, Géricault's work can be discussed as an artistic performance: his style, his aesthetic rank in our scale of value judgments, and related problems which have been little studied until now. It hardly needs to be said that this classification is artificial, that one aspect often merges into another, and that therefore overlapping is inevitable. Nevertheless, this seems the best way not only to publish a number of hitherto unknown works but also to show the importance of Géricault to his time and to our own.

II. Life

"He was at once animated and gentle. . . . Tall, grave, with singularly beautiful eyes, dreamy, mild, and deep, like those of Orientals." This description comes from Adélaide de Montgolfier, an intelligent woman who knew Géricault well. A man's impression: one night about 1823 a friend met him at the entrance to the opera, "in the midst of a cheerful crowd, with ladies in

evening dress, and a hubbub of carriages and lanterns. He himself was in formal attire, with yellow gloves, but already sadly changed. The infinite mildness of his gaze had been eclipsed by the harsh expression of a terrible mask" (Michelet, *"Cours du Collège de France 1847-48,"* in *L'Etudiant,* 1877).

Elegance and a gentle temper are the outstanding traits which many witnesses remarked in him. In whatever company he appeared, he soon attracted everyone's interest and attention to his person. He had little small talk, but his very presence had an effect, especially on women, and drew people of all ages and occupations into his orbit. Those who met him only once retained a strong and indelible impression.

To judge by his existing *œuvre,* he must have been a steady worker, yet his friends seldom saw him painting. The professional current in his life was kept in the background, and he appears as a sociable, open, sport-loving, active man with a warm heart and sensitive character, who (aside from his art) was fascinated by unusual sights and events and by the operations of destiny. He followed politics, the theater, literature, and music, and concerned himself with social and scientific questions. His friends were writers, physicians, economists, military men, and of course painters; but women played a more decisive role in his life. He fell in love easily and often; one single great love brought with it gloomy and tragic tones which overshadowed his last years. Here begins the "secret" of his existence, to end no one knows where, and to leave circles of influence in everything that he experienced, touched, or created.

He never had to earn his living. Considerable means, inherited from his mother, made him independent; the satisfaction of his material wishes could be taken for granted. Visits to the opera and the theater, excellent clothes, and the ownership of a string of horses were natural in his social set.

Born in the middle of the French Revolution, he grew up a witness of the meteoric rise of Napoleon. The catastrophe of "the greatest man who has appeared in the world since Caesar" (Stendhal, *Vie de Napoléon,* p. 1), a human event in the highest style of Greek tragedy, fell when Géricault was twenty-one. A thousand evidences tell us that the event shook an entire generation as if with the weight of a religious convulsion. It certainly affected Géricault. The idea was borne in upon him that every society demands its victims, and that the sacrifices of his own time were among the most intensely interesting. This became a sort of undercurrent in his art.

Another circumstance in the quite private sphere of his life points in the same direction: the loss of his much-loved mother when he was ten years old. If we are to give credence to modern psychology, the nature of the adult

can be explained by experiences of early childhood. Géricault's relationships with women, including older women and married ones, may thus be connected with a fixation on the lost mother. This is the tragedy of Hippolytus and Phaedra in modern dress: the youth whose body is broken on the rocky shore may also be seen as a sacrifice to society. Géricault knew the fable well, and he did not paint it by accident. Significantly, he gave his son the name of Hippolyte.

The life that was lived under the constellations of Napoleon and Hippolytus began calmly and securely enough. Jean-Louis-André-Théodore Géricault was born on 26 September 1791 in Rouen. His father, a jurist who made a fortune in tobacco plantations, is reported to have been artless and inaccessible; no doubt the only child was all the more drawn to his mother. She was interested in music, literature, and cultural questions, and she gathered in her salon the distinguished people of the provincial city. Her family, the Caruels, were Norman, and of the well-to-do bourgeoisie. From her the son got the charm which everyone who knew him mentioned.

The move to Paris, the death of his mother, the education at a boarding school, followed by bad results at the Lycée Impérial, interrupted by vacations in Normandy and rides on wild horses—these were the major events of his youth. His talent for drawing showed itself at school, but his insatiable interest in horses attracted more attention. He spent many evenings in the Cirque Olympique, with whose director he made friends; and there during free hours he was allowed to mount into the saddle.

On 1 July 1808 Théodore left the Lycée's fourth class, and began his art study. The succeeding period lasted six years, and can be divided into three phases according to teachers: for the first two years Carle Vernet, then for a few months Pierre-Narcisse Guérin, finally the old masters in the Louvre, whom he unceasingly studied, copied, and paraphrased.

The choice of Carle Vernet is a surprise: what could Géricault learn from a painter who doubtless made an elegant brush-stroke but who, when he began to draw a horse, got entangled in feeble mannerisms? Later Géricault would be heard to say that one of his horses could eat up six of Vernet's. But at the moment he was happy, for despite his father's initial objection he could take the first steps in art instruction; furthermore, he was in a place where at least they painted horses. The remarkable thing is that he stayed as long as two years; perhaps it can be most simply explained by the development of a great friendship with Horace, the son of his teacher. The tie formed there lasted to the end of his life.

Much weightier was his work in Guérin's studio. Here he found himself in a focus of artistic life, where he could learn the then sovereign theory and practice of Louis David from familiar acquaintance with one of his closest followers. However we may appraise Guérin's work—and it has never stood high, at least in the market—he was certainly a first-class teacher. In a rather restricted sense he was the last teacher who kept a hard school; for the Romantic overemphasis on inspiration and imagination soon destroyed forever the old apprentice-like training, five-finger exercises, and traditional skill of hand, putting all artists in the category of the self-taught. Guérin's studio cannot have attracted the younger generation only because it was modish, nor can his instruction have been so dry and doctrinaire as is thought, for not a few of the Romantics first met in that atelier. Géricault made the acquaintance there of Léon Cogniet, later his collaborator, of Champmartin, Paul Huet, Ary Scheffer (who painted him on his deathbed), Dedreux-Dorcy (perhaps his most intimate friend), and Champion, whose earlier work is completely lost but who (according to Delacroix) was a friend of Géricault's youth and greatly influenced him.

We do not know how the instruction in Guérin's studio was carried on in detail, but we should not be far astray if we assumed that it was managed much like the studio of Girodet-Trioson, who was another follower of David. Girodet-Trioson, indeed, "took a lively interest in his pupils; he noticed their sketches from the beginning, cultivated an early-maturing talent with the most sensitive and paternal care, with the wise zeal of an educator. . . . As a basis for learning, the young naturally had the master's pictures to copy, either the original canvases or prints after them. . . . Then they studied the antique, the statues in the Louvre, of which Girodet had many casts, the *Fighting Gladiator,* the busts of Emperors and philosophers, *têtes d'expression* from the antique and from nature, drawn by the master himself. . . . They set great store by Greek and Roman coins, not only for their beauty but because they were useful documents. The interest in antique coins was then general. . . . Finally, Flaxman's illustrations of Homer, Aeschylus, and Dante kept the cult of line alive. . . . Girodet gave Michelangelo first place among the painters of Italy. . . . The master always demanded the representation of a play of muscles and of tragic-heroic gestures. . . . The older students drew from the living model, who was sometimes a very correctly dressed girl but more often a man. Devéria [one of the pupils] made head-studies from Leduc, who was then the model in the Academy and also floor-polisher of the Louvre, and from a Negro who was astonishingly ugly. Studies of a Turk by him are also known" (Jean Ad-

hémar, *"L'Enseignement académique en 1820. Girodet et son atelier"* in *Bulletin de la Société de l'Histoire de l'Art Français,* 1933, pp. 270-279).

A point that should not be overlooked, in view of Géricault's later development, is that Orientals as models were already included in the classicistic curriculum. Perhaps we might see in this the first sign of the approaching Romantic storm, a longing for freedom, a turbulence that was long under cover. Châteaubriand and Madame de Staël were part of the literary fodder of this generation, a generation for whom the widely read translations of Byron and Scott would soon open new horizons of adventurous fantasy and color; for Byron appeared in Amadée Pichot's French translation in 1822, and Defaucoupret's translation of Scott belongs to the same year.

What was Géricault's situation in the atelier? Was he from the beginning a leader in the uproar of protest against the ossified academic methods? Did he, with genial ardor, stand sponsor to modern painting? This is an important point, because the legend of the "first Romantic," the daemon-ridden boy obsessed by thoughts of death, the fantastic mixer of color and tone, still finds support and is used as a contrast to the David school.

Géricault's temperament in painting was known to be unusually brisk. If the model's right arm is raised, he immediately paints a variant for the left; once, it comes into his head to provide a nude with a background in the style of Paolo Veronese; he loves lively, rosy coloring; he lays his colors thick and models the paint itself; hence he gets the nickname of "Rubens' chief cook." He makes himself known as a self-sufficient talent, not too docile, and that is about all. The teacher, says Clément, is disturbed only by one thing, the great influence this young man soon exercises over his fellow-pupils, and he exhorts them: "Why do you want to follow him? Let him go his own way; he has enough stuff in him for three or four painters." This does not sound as if Géricault had declared war on his elders, or deserted, or mutinied. On the contrary, Guérin always shows the greatest interest in his pupil; the latter on his part submits large works to his master's judgment, even years afterwards when Guérin appears at a private showing of the *Medusa.*

Biographically, it is an interesting question whether Géricault at that stage displayed any definite deviation from contemporary norms. Until now, people have satisfied themselves too easily with traditional formulations, not probing into the facts. Régamey (pp. 12-13) sets this right: "Géricault was not the only one who loved a firm succulent stroke. From the height of the Empire on, it has been possible to recognize in some young painters a return to sensuousness, which the Davidian reform had reduced almost to nothing; at least its

expression had become rare in 'high' painting, yet in sketches and studies it showed itself always powerfully present, especially under the amazing brush of Girodet-Trioson. Even realism, far from being a reaction against the direction of David, was as true an expression of Davidism as abstract idealism was; realism was one of the principal tendencies of Géricault's generation."

The outcome of the study at Guérin's was therefore an acquaintance with the theory and practice of the Neoclassic school, plus the slowly ripening realization that what mattered most was to work within it, not fight it, that "only that temperament is original which adapts itself to the inspiration and style of the school and at the same time develops a new accent" (Régamey, p. 13). In six months Géricault probably learned what was learnable of this art, and opened his own way to the reintegration which he sensed from afar, and which he must now make possible by his own efforts. His guidepost was the living art of all times.

Never were such masterpieces of sculpture and painting gathered together in one place as in those years in the Louvre, renamed the *Musée Napoléon*. To the world's greatest empire belonged the spoils of the world's art, at least according to the constructive ideas of that generation, which experienced the collapse of the old régime and the retreat of the "enemies of freedom" on all fronts. With a clear conscience the sons of the revolution and helpers of the "democratic" Emperor fetched all the greatest portable works of art to Paris, to free them from "the narrowness of their reactionary surroundings." The sculptures of ancient Rome, pictures from Spain, Italy, the Low Countries, classic and Baroque, all were there.

Géricault is the first painter who found there an all-embracing opportunity for artistic schooling upon original works of the masters. He spent days, weeks, months in the museum. The result is countless pictures which can be considered copies only in the sense that they follow their prototypes in construction and arrangement of forms. The strong handwriting of the young painter shows itself unmistakably and with growing assurance; seldom are the color tones left unchanged, and the interpretations are so individual that one thinks he has a new and original work before him. Clément knew thirty-two such studies, but in the face of current knowledge that number must be much enlarged; if we were to include all the "borrowings" in Géricault's work the list would grow beyond enumeration.

The rich impasto and painterly stroke of the Baroque is dominant in these "ancestors": Rubens and Salvator Rosa, Le Sueur and Caravaggio, Spada and Velázquez, Rembrandt and Jouvenet, Bourdon and Weenix, Van Dyck and

Rigaud, and along with them an interest in classical composition after Raphael, Giulio Romano, and Titian. Géricault's style forms itself by probing further possibilities rather than by the application of a narrow theory; thus it points out for later generations a way which cannot be neatly trapped in the alternatives Classicism or Romanticism.

The study of old masters and the attachment to tradition are not limited to his early years; these tendencies run through his whole creation. His new adjustment can be recognized especially in relation to antique sculpture. Instead of studying from plaster casts and prints, as was the custom of the school of David, he works from originals, and finds in reliefs of the Hellenistic sarcophagi a stylistic "parallel" which is most helpful to him in his own problems (pl. 20). Unconsciously he follows the example of Poussin, almost two hundred years afterwards. For this discovery he was indebted only to his instinct, not to a teacher, for it was only two years since the Borghese collection was absorbed into the Louvre (1808), and hence it had not yet been put to regular use for instruction. Whoever walks today down that row of twenty ancient compositions finds the stylistic and iconographic roots, and many of the single motifs, from which Géricault imbibed the strong waters of inspiration to the end of his life.

Two autographic witnesses tell us this early history. One is the so-called Zubaloff Sketchbook, now in the Louvre. In this, a sort of picture diary, we accompany Géricault to the theater, see how he nailed down the expressions taken by the performers of certain roles, or the grouping of a scene; we go to the Louvre and see how he studied imperial portrait busts, antique statues, nude or richly draped; how he worked to unite a harmonious line with the full forms of the Renaissance; above all we wonder at his "composition studies from sarcophagi and bas-reliefs. The artist chooses powerful subjects and tumultuous crowds, battle scenes, sacrifices full of motion. . . . In their masculine austerity, these drawings in black ink remind us of David's sketches, which look as if engraved with a dagger-point, or of Poussin's drawings from the figures on the column of Trajan" (Oprescu, pp. 20 ff.). The other document, a memorandum on Géricault's work program, is given by Batissier (p. 5):

Draw and paint from the great old masters—read and make compositions— anatomy—antiquities—music—Italian.
Thursday and Saturdays at two o'clock attend lectures on the antique.
December—paint the figure at Dorcy's—in the evenings draw from the antique and work on composition—busy myself with music.
January—go paint from the model at Guérin's.

February—occupy myself solely with the style of the masters and with composition, *not going out and always alone.*

These lines must date from the time when he had already quit Guérin's atelier as a regular student, for it is known that he returned there occasionally to work from the model. When we consider that among the last pages there are studies for the *Wounded Cuirassier* of 1814 (pl. 8), we can probably accept 1813 as the date of the notebook. Géricault's studies from the antique would have, then, a much broader basis than was formerly assumed, spreading over three years of his own hard work, and not simply deriving from the foolish school discipline. With his temperament, he turns his experience of the antique from an archaeological program into a preparation for living art.

In the middle of this period, he finishes his first large work. The *Chasseur Officer on Horseback Charging* (pl. 2) appears in the Salon of 1812. The dimensions are out of the ordinary, the height being nine and a half feet. He is said to have finished the painting in twelve days. If we count in the preparatory studies (examples in pls. 1 and 3), we must think of it as two months' work, says Clément: a great thing to have tossed off, and a bravura performance in its bold motion, its well-set composition, and its glowing color. Contemporary criticism (Delpech, *Salon de 1814*) saw in it an out-and-out success: "Harmonious tone, powerful originality, and the swinging energy with which the picture is painted from end to end, allow us to overlook the few errors which seem to have escaped the painter." Modern stylistic criticism recognizes various elements borrowed by the painter from his sources and combined into a highly original and strong unity: the boldly constructed plan, like a geometrical figure, comes from his teacher Guérin; from Gros, the most self-willed and dynamic follower of David, come the color, the *facture* or handling of the brush and paint, and the type of the cavalryman (Régamey, p. 19); nor had he studied Rubens and certain antique prototypes in vain. Géricault received a medal, but the State did not buy the painting.

In the next Salon, 1814, the *Wounded Cuirassier Leaving the Field* (pl. 8) was shown as a sort of pendant to the *Chasseur Officer*. The new picture had areas of ravishingly beautiful painting, but the critics would not forgive it certain ill-drawn passages, especially in the legs and rump of the horse. Géricault, in exaggerated self-criticism, is said to have exclaimed to friends that the cuirassier's head was not worth much, the eye did not fit right in its socket; on another occasion he said, "There is a calf's head with a great stupid eye!"

What false estimate can have caused him to paint this gigantic picture and show it to the public at a time when he had on hand a long series of wonderful

studies (pls. 4-15, color pl. I)? What self-deception drove him to the over-life-size format and allowed him to overlook the greater monumentality and grandeur of his small pictures? Probably the explanation can be found in the uncertainty and tension which not only filled his own inwards but which in that year kept France's heart in her throat—and all Europe's. Napoleon's fall and return from Elba drew all eyes to the political arena; worlds were collapsing overnight, the ideals of generations broke down in an hour, and the fate of the democratic revolution was decided by a single battle. Géricault's malaise and youthful impulsiveness drove him to participate. And here he took a step which he would have been glad, later on, to revoke. At the return of the Bourbons he enrolled as a musketeer; instead of painting horses and uniforms he was now going to be in the midst of them. During the "Hundred Days" he was in the suite of the fleeing King on the way to the Belgian frontier. "In the night we went to the Tuileries; the court was cluttered with howling people, and when I saw the cowardice of all those soldiers who were throwing away their weapons and disowning their allegiance, I resolved to follow the King" (Clément, p. 67). A short time later, his mission was ended and he came home a civilian.

The outcome of his love affair, the great turning-point of his life, was no happier. It was simmering at this time, and it embroiled his entire existence. From the end of 1815 to the middle of 1816, says the conscientious Clément, there was a complete interruption of his artistic work (pp. 67, 70, 75, 77). Glowing, passionate, and consuming were his relations with the beloved, the wife of one of his best friends. No one has broken the secret of her identity. Géricault tried to pull himself away, and left Paris for a whole year. In 1818 a son, Hippolyte-Georges, "of unknown parents," was born, who was allowed later to take his father's family name. The son spent his life hunting in vain for his mother, until he died obscurely in 1882. This is all that the sculptor Etex can tell us (*Les Trois Tombeaux de Géricault*, 1885). In this mystery, at all events, lurks the secret of Géricault's life and character, and this is the source of the fate that now lays hold on him and in a few years will shatter him, setting the highest fortune before his eyes and snatching it away when he reaches for it. From here on, Géricault is in flight. He climbs deceptive heights and sinks into abysses lighted only by the twilight of mental darkness. Perspectives of social guilt open before him; actors from the new society are vested with the great forms of tradition; a world in process of industrialization reveals itself to him in epic colors. Everywhere he discovers menace, human drama, a constant forcing-up of life to the edge of death; but in spite of all this, it is not the romantic-pessimistic desire of oblivion that drives him; it is

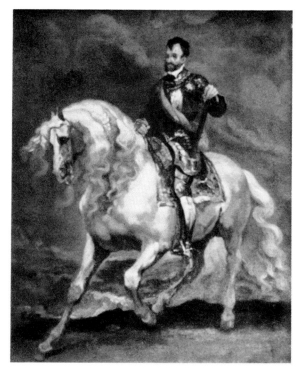

Fig. 1. Géricault, A King on Horseback. After Van Dyck. Bradford, Pennsylvania, collection of T. Hanley

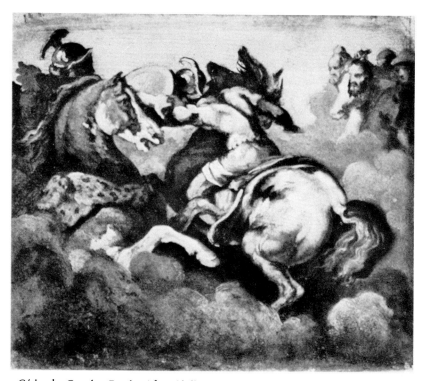

Fig. 2. Géricault, Cavalry Battle. After Giulio Romano. Forest Hills, Long Island, Richard Zinser

Fig. 3. Géricault, Boxer on His Knees. Bayonne, Musée Bonnat

Figs. 4 and 5. Géricault, Trapeze Performers. Bayonne, Musée Bonnat

rather the stoic and epicurean legacy of antiquity, with its sense of form and order, that tragedy brings to his mind.

The stay in Italy, long wished for, and prepared by study of its painters, began in the autumn of 1816. Géricault was just twenty-five. Like so many artists in the centuries before him, from Dürer to Poussin and Fragonard, he was able, in the artistic climate of the south, to find himself. This second birth was not always happy or easy, but was accompanied by woeful sorrows. Under the frescoes of the Sistine Chapel, he was at first depressed by his own limitations. This mood lasted until he gave himself up to taking the measure of those giants, capturing their relationships, pulling them down into his sketchbook, and possessing himself of this treasure of form. He worked constantly, saw, noted down, copied, and varied in his own way works of all schools and artists, preferably those whom he considered "approaching antique form." Sarcophagi, the Raphael of the Farnesina, and Michelangelo stood first. The numerous gouache studies (pls. 22-25) show an astonishing mastery of the arrangement of motion-filled scenes in planes. He is full of figures, discoveries, ideas for compositions. He sketches passers-by in the streets, churchgoers (pl. 21), everything *"d'après nature,"* and in a hand's turn he makes a big-boned picture from them. Nevertheless, he is in no way happy. Neither of the two friends, Dedreux-Dorcy and Lebrun, whom he begged to accompany him, has come along. He is alone, and the *"chagrin d'amour"* weighs on him. Three letters, whose text has been preserved [if not their paper], are full of this melancholy. He complains of the lack of news of his friends, and goes on: "I had come to the point of accusing everyone of indifference and inhumanity, and I should have been glad not to remember a single soul. It seemed to me impossible to live any longer in this state, which was horrible and inconsolable. Now I can speak of it with a certain pleasure because the uneasiness is past. . . . At present I am fairly happy, I only lack a friend to live and work with. Alone I am almost incapable of work; my heart is never at peace, it is full of memories. . . . How my friends are, what is happening in Paris, and a bit of politics to boot—that would make a really interesting letter that would keep me abreast of everything that goes on at a distance" (to Dedreux-Dorcy, 27 November 1816). Again he writes to the same: "Now I am subject to wanderings of mind; in vain I seek something to lean upon; nothing is solid, everythings runs away from me, everything cheats me. Our hopes and desires here below are really nothing but empty chimeras, and our successes are phantoms which we think we can grasp." But in between, he had moments of peace and indeed of good cheer. From Florence, where he spent nearly a month, he

wrote: "I have first-class friends here. Yesterday evening I was at the opera in the French ambassador's box; my shoes were soiled and my dress unkempt. Nevertheless I had the place of honor besides the Duchess of N., who was going away to Naples the next day, and to whom the ambassador warmly recommended me. . . . She spoke much to me of my modesty, and assured me this was a mark of talent; see how they flatter me. But this was not unexpected" (to Dedreux-Dorcy, autumn 1816, cited by Batissier).

Self-discipline was the valuable experience that Géricault owed to his stay in Italy; perhaps he could only have attained it there, under stimulus from great works of art in their own climate; for his naturally changeable, almost romantic character and his financial independence had hitherto held back his great talent from major performance. He needed resistance, difficulty, and doubts, in order to give of his best. The classic exprience of Italy made him capable of his highest task, as his later products show.

This year of clarification, most of it spent in Rome, offered interesting friendships with other artists. He made the acquaintance of Victor Schnetz, a rare mixture of the David pupil and the "discoverer" of paintable beauty among Italian gypsies and bandits; Schnetz took him to the studio of the then still unknown Ingres, where he admired those beautiful pencil drawings in all the purity of their line, long before anyone else had appreciated their artistic quality. The meeting which probably had the most important consequences was with "Monsieur Auguste," a winner of the *prix de Rome* for sculpture, who soon changed over to painting and became well known as one of the chief forwarders of Orientalism. Géricault owed to him not only his introduction to the young Delacroix but also the first declaration of sincere admiration for his work—an admiration which did not cease with Géricault's death but was afterwards transferred to the Romantics.

Apparently Géricault did not meet Stendhal, though both were in Rome at the same time, and they had many friends in common during their lives. It is a pleasure to imagine their meeting, when they might have talked of Napoleon, Raphael, Michelangelo, the worth of contemporary subject-matter, the sharpening of form, or spiritual sensitivity, or love and passion. One would like to have heard those two, men born out of their time in ideas and judgments, drawing parallels between literature and painting. But there is no occasion for supposing that one even knew of the existence of the other. "In Italy no one can parade his vanity [for long]; everyone has to live on his own resources, he cannot lean on others." This is from Stendhal's *Promenades dans Rome,* but could have been formulated at the same time by Géricault as a

resumé of the Roman year. He had drunk in the great tradition, and in doing so he had found himself.

When he returned in the autumn of 1817, he brought from Italy all the sketches and studies for the *Race of Riderless Horses* (pls. 26-29). An actual event is here permeated with classical form, and visualized with such monumentality that all merely picturesque effects fall away.

In Paris, Géricault was received into a circle which we could call, because of its meeting-place, "Horace Vernet's Atelier." Géricault's new studio was close at hand in the Rue des Martyres on the slope of Montmartre, in the newly built *"Nouvelles Athènes"* quarter. The members of the group had in common a dissatisfaction with, and critical feeling towards, the stuffiness of the reigning Restoration; they yearned for freedom, for activity, for the vanished age of Napoleon, of which one participant said, "We were born to see the most extraordinary things" (*Mémoires du Général Bro,* Paris, 1914, p. 46).

There the liberal opposition gathered: generals who at the age of forty had been put in the reserve, colonels of thirty, with such names as Foy, Lamarque, Bro; the "treasonable" Deputy J.-A. Manuel, Béranger the poet of freedom, Antoine-Vincent Arnault, biographer of the Corsican, and even the future king Louis-Philippe, who was nicknamed "Duc de Valmy" in memory of the Revolution. Vernet's was one of the places where the Napoleonic mythos was built up in night-long discussions. If it is not absolutely certain that Géricault ever saw the Emperor, there is no doubt that, through information from those enthusiastic eyewitnesses, he made himself master of the Napoleonic color and iconology. The memoirs of General Bro, first quoted by Régamey but probably never recognized in the full breadth of their meaning, are highly revealing: they give both the substance and the mood, the words and music, so to speak, from which sprang a whole group of Géricault's pictorial ideas. It was probably no accident that the artist was attracted to this man who had made the German, Austrian, and Russian campaigns, who had come to know the psychology of the Negro on an expedition to Santo Domingo, and who surely spoke at Vernet's as interestingly as he later wrote. "Military Slavery and Grandeur"—so runs the title of a book by his contemporary Alfred de Vigny—the brilliance and misery of Napoleon's comrades-in-arms receive in Bro's book such close-up treatment that on many pages one is reminded of scenes that Géricault painted or might have painted (cf. pls. 5, 13-15).

From the mixture of politics, literature, and art in Vernet's circle Géricault got a more coherent philosophical view of his own experience and ideas. He now became an active liberal, and allowed himself to be led by this decision,

at least in part, when he was choosing subjects. Instead of ancient fables, we see contemporary themes walk onto his stage, though his interest in many-figured "Roman" compositions continues. The *Subduing the Beeves* (pl. 32) and the *Camp in America (Champ d'Azyle)* both belong to this period, and the *Raft of the Medusa* begins to take form in drawings (pls. 42-45).

Also in 1817 Géricault turns to lithography, and is one of the first to realize the expressive artistic possibilities of the new graphic process. Within two years, twenty lithographs appear, many of them dramatic scenes in which grandly moving horses dominate: *Two Dapple Greys in the Stable* and *Mounted Artillery* (pl. 62) are recognized everywhere as masterpieces. No fewer than seven illustrate the story of the Napoleonic army. What a challenge to a period when the Bourbons ordained absolute silence about the very existence of the Emperor! These lithographs, despite their tremendous verve, the originality of their surface tone, and the richness of their composition, were honored only by artists and connoisseurs; with the public they had but limited success. This is probably the reason why only one of these motifs was carried further toward painting-format (pl. 16).

Still another world opened before Géricault in these years: that of animals (pls. 34, 36-38). Instead of letting the inspiration of classical compositions pour over him, as in Rome, he pursued his studies, in the company of his new friend the young Delacroix, in front of the cages in the Jardin des Plantes. It was like the discovery of a new land for art, a breaking of the canons of a school that had allowed only the human figure. He must have thought often of Rubens and Snyders; he made a variant of a picture by the Englishman Stubbs.

As always with him, the crossing of the old prototype with inspiration from nature leads to the creation of something new, having more character than has been seen before. His cats and bulldogs (pls. 34, 36, 37), his tigers and lions (pl. 38) look as if they had been part of Géricault's world from the beginning.

The sculptures must also date from these years, for in no other period was his grasp of anything new both so sure and so light of touch. Clément knew four of the six pieces actually executed; today we must be satisfied with only two (pl. 95). The renunciation of color and the working out of significant form mark Géricault's efforts so strongly at this stage that the crossing of the border from one art to the other seems the easiest thing in the world. He needs no instruction in technique. The story is told that one day he was toiling to cut a relief in the wall of his studio with a wood-chisel. His friend Jamar saw this, rushed out to the street, found some stonecutters, and bought tools from

them; with these the sculpture was finished. Géricault has been called a frustrated sculptor by more than one critic, and with some reason.

Many a biographer, from the point where his hero has reached full development of his capabilities, will spread a mantle of silence over events which may spoil his appearance. Let us not make our man a plaster saint. At Vernet's Géricault fell in love with a charming Creole, Madame Lallemand. Her husband, a former officer of the imperial army, was trying to build a new life in America, having bought shares in the Champ d'Azyle, an interesting settlement project for disoriented Buonapartists. Bro, as an eyewitness, writes quite openly of the love-affair; not knowing of the previous affair, its resumption after the return from Italy, or the resulting child, Bro was able to look at the new affair as an uncomplicated event.

Warned by his too hasty picture-schemes in the past, armed with knowledge of the art of the masters whom he most admired, already rich in experience of the world, and well knowing the political evils of his time, the twenty-seven-year-old Géricault addressed himself to the greatest hazard of his career, a painting of more than forty square yards. Even though it should shake the world with its theme, he must have said to himself, there was no wall in France where it could hang, except in the museum. His preparations extended over the spring and summer of 1818; in November he rented a big atelier in the region of St.-Philippe-du-Roule, had his hair cut so short as to prevent his going into society, and lived many months as his own prisoner. On 25 August 1819 the Salon opened with the finished work on exhibition; all told, it had taken sixteen months from the first sketch to the last brush-stroke (pls. 41-53).

The external impetus to the painting of the *Medusa* was the printing of detailed information, signed by Corréard and Savigny, on a shipwreck near the west African coast; 149 passengers of the *Medusa* were put on a raft and taken in tow by rescuing vessels, but the hawser broke and for twelve whole days the helpless people were exposed to truly inhuman torments on the high seas. "Hunger, thirst, and despair drove them against one another." Only fifteen completely exhausted beings were still alive when help again drew near. (For his own reasons Géricault painted nineteen.)

The impact of this news was tremendous; the book ran to edition after edition, and was promptly translated into English and German. It is hard to say whether this success was due mostly to the graphic portrayal by eyewitnesses, to the adventurous human elements in the story itself, or to the political overtones, which amounted to an unmasking of the Bourbon Restoration; for

the incompetent captain of the *Medusa,* an elderly and reactionary *émigré,* owed his appointment to government patronage.

In the combination of these various factors Géricault recognized, as he would later in the Fualdès story, his sort of raw material: "the strife over the prostrate fatherland, the aimless confusion of a rudderless generation," so Batissier interprets the theme of the picture. Géricault got in touch not only with the two authors but with other survivors. Like a modern reporter, he wanted to know just how it all had happened. He had a model of the raft built, studied the expressions of persons *in extremis* and the look of newly dead corpses, which he procured from the neighboring hospital and the morgue (pls. 51-53, color pl. III); his atelier began to look like a slaughterhouse. He made physiognomical studies, some of them, notably, of Negroes,—three of the survivors were of dark races,—he listened to the desperate and watched the deranged wherever he could find them. To a friend whose face was transformed because he was suffering from jaundice, the artist exclaimed, "How beautiful you are!" and hastened to fetch his paint-box in order to incorporate this observation into his material. He made a short trip to Le Havre to look at the action of waves. The innumerable sketches in pencil and pen, life-size portrait studies of the participants, monumentally painted death's-heads, arms, and legs (pl. 53), which have come down to us, show what new territory his grandiose artistic vision opened up for representation.

The distribution of so many figures and compositional elements over the colossal surface seems to have offered the greatest difficulties. No painter of the 19th century was at ease in constructing large compositions. Géricault remembered the old masters, perhaps Michelangelo more than all the rest, and settled, after much vacillation, on the scene with the rescue ship in sight and on double diagonals as a scaffold of form (pls. 42, 43), but at the last moment he discovered a "hole" in the lower right. Shortly before the opening of the exhibition he changed his scheme, and inserted a new figure. Was the improved work now proof against the attacks of critics?

The only one who, according to Clément, did not show himself dissatisfied was Géricault's old teacher, Guérin, who came for a private view and stayed almost an hour. Gros, to whom our painter felt a sort of foster-relationship and whose judgment he certainly valued more, had previously called him the most promising of the younger artists; after seeing the *Medusa,* he said only that Géricault needed to be bled of his excess. Professional criticism was divided; no one was greatly moved, no one saw anything essentially new bursting out of this work. Clément sums up: "From the beginning of the

Salon, the general impression was bad. The enemies of the young reformer triumphed. Even his friends were sharply disenchanted: in the studio their hopes had been raised and their wonder aroused, and they hardly recognized the painting at the exhibition (it was hung too high)." But among the general public the waves of excitement mounted. Rosenthal writes (p. 97): "Géricault's success rested not only on his artistic qualities. If he wanted to provoke a political scandal, he calculated only too well. The government would not allow the name *Medusa* in the catalogue, and substituted the harmless title, 'Ship-wreck Scene.' The public quickly restored the right name, and political sympathies were given free rein. Some congratulated Géricault on his courageous attitude as a citizen, others blamed him severely for his choice of subject. Whoever let the *Medusa* stir him to sympathy, indirectly brought the government of Louis XVIII into disrepute."

Géricault himself complained in a letter about the injustice done to his work (Batissier, p. 14): "This year our journalists have reached the pinnacle of the ridiculous. Every picture is judged first on the spirit in which it is painted. So you will hear a liberal writer praising the patriotic brush-stroke or the nationalist color of a certain work. The same one, judged by a reactionary, is not only a revolutionary composition dominated by a generally seditious tone, but also one in which the faces are filled with an expression of hatred for our paternal government. Finally, I have been accused by a certain *White Banner* of having libelled the entire Navy Department in one 'character' head. The poor creatures who write such nonsense have doubtless never yet gone fasting for fourteen days, else they would know that neither poetry nor painting can reproduce with adequate horror all the anguish suffered by the people on the raft." The painter of the *Medusa* must have been glad, after all, to receive a medal, though nothing was said about the State's buying the picture. An official commission for a religious painting was indeed given him, probably to help turn his ideas to a more conservative channel; he was not interested in it, and was satisfied to turn it over to his young friend and protégé Delacroix, who was poor and still unknown.

Disappointed if not quite "deeply discouraged" by this misfiring, Géricault wanted to get away from Paris; for a moment he thought of giving up painting altogether and entering on a life of adventure in the Orient. Then, on the spur of the moment, he decided to go to England. In the first days of January 1820, immediately after the close of the Salon, he was in London, accompanied by the well-known print-maker Charlet and by his friend Brunet, a young political economist whose father, a friend of Bro's, had taken part in the ex-

pedition to Santo Domingo, had been captured soon after his return, and had
spent twelve years (1802-1814) as a prisoner in England; it is not clear whether
the son's trip had any connection with this captivity.

One of Géricault's first errands took him to an Englishman named Bullock
who, shortly before, had shown Lethière's picture *Brutus* from town to town
for a fee, making a colossal sum of money. Géricault made a similar arrange-
ment with him for the exhibition of the *Raft of the Medusa,* the artist to re-
ceive one-third of the net profit. The great canvas was rolled up, shipped over
the Channel, and carried from stage to stage throughout England and into
Scotland. This showing must have made a sensation in the provinces, for the
attendance was large, and the income corresponded. The astounding sum of
£850 gold was the artist's share (about $20,000 in 1953 purchasing power).
The dandy of yesterday had become an entrepreneur and businessman. We
cannot tell from the documents whether he traveled with the picture as far as
Dublin or stayed in London; between 23 April 1820 and 12 February 1821, the
dates of two existing letters, there is no trace of him or of any work of art of
his creation.

Michelet and Delacroix, after many years had passed, felt free to say that
Géricault, leading a dissolute life in London, had caught the germ of a fatal
disease. Jules Michelet, famous historian, writes in the *Revue des deux mondes*
(15 November 1896), in a posthumously published essay: "If he became ill be-
cause of his relations with his one-day mistresses, he blushed and said, 'How
should I find the courage to dishonor such a charming creature by my dis-
trust?'" Delacroix (cited here from Piron's *Eugène Delacroix,* Paris, 1865) re-
marked: "Misfortunes, resulting from the violence with which he pursued
love and everything else, weakened his health terribly." But as one of these
reporters never knew him, and the other, during his lifetime, always kept a re-
spectful distance, these unsupported utterances can probably be taken for fanci-
ful speculations. Not the slightest hint on the subject can be found in informa-
tion given by his friends.

It is true that, from the English period on, an overpowering restlessness more
and more took possession of him. Did he feel that he had not always used the
vanished years for the best? Did he sense the nearness of death, which would
leave him so little, only three years more to use? Even if we do not accept as
authentic the attempt at suicide about which Batissier, his biographer, knew
nothing, and which is first mentioned thirty-five years later by La Combe
(Colonel de La Combe, *Charlet,* 1856, p. 19), Géricault's behavior is certainly
erratic. Despite his comfortable means, despite his fantastic income from the

Fig. 6. Géricault, Figures from a Persian Miniature. Paris, private collection

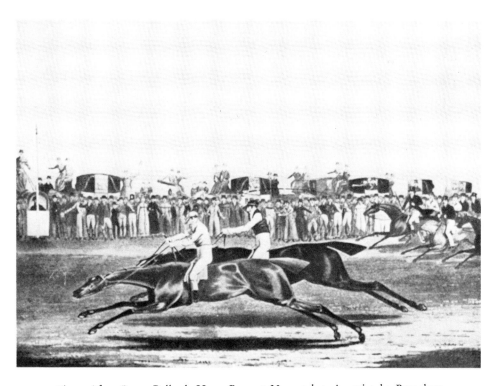

Fig. 7. After James Pollard: Horse Race at Newmarket. Aquatint by Rosenberg

Fig. 8. Girodet-Trioson, The Oath of the Seven before Thebes. Bayonne, Musée Bonnat

Medusa tour, he thinks of nothing but making more money. He signs a contract with the printer Hullmandel for a series of lithographs, an "inconceivable rage" for which he notices in London. "With just a little more persistence than I have," he writes in a letter, "I am sure one could get quite a fortune." A couple of lines farther down he comes back to the same subject, and speaks of his plan to shut himself up in a stable which "I shall leave only when I am embroidered with gold." What a double disappointment he must have felt when he found himself defrauded of his expected gains by the publisher, and obliged to pay the printer out of his own pocket!

So little is known in detail about the English period, and we can lay hold on so little of the milieu in which he moved or the people with whom he had connections (save that Clément mentioned in three words "a new conquest"), that two facts only can be taken as evidence for the happiness and fruitfulness of the time. These are the length of his stay in England and the calmer tone of his correspondence. It is unknown whether he made friends with English painters, but he certainly must have become acquainted in person with the two most renowned, Lawrence and Wilkie, as I have shown in the article, "David and the Development of Géricault's Art" (*Gazette des Beaux-Arts,* 1945, pp. 41-62). At first with reservations, then with growing wonder, he expresses himself in letters about the painter-like qualities which he discovers in genre and landscape works by his English colleagues. He especially likes Constable and, the latter having had as yet little recognition, Géricault can list him almost as his own discovery. Delacroix and others of his friends hear him declare himself, after his return from England, "altogether intoxicated by one of his [Constable's] great landscapes" (letter from Delacroix to Théodore Silvestre, 31 December 1858, printed in Silvestre's *Les Artistes français,* Paris, 1926, vol. 2, p. 157).

In order to understand the historical and artistic importance of the English visit, we can only turn to the works created there. They are readily recognized by the soft atmosphere with which they are filled, their rather loose watercolorish way of seeing things, and the objective interest in social situations: the contrast of rich and poor, of abundant health and death-laden misery; these and the important role of sport and business specially impressed the stranger with the practiced eye. Géricault's field of vision and interest broadened tremendously. One has only to see the horses that he now drew and painted, and to compare them with those which were created earlier; it is as if he had previously known only a type or two, and now all at once the horse has been revealed to him as a countless number of individuals.

The English experience in art and life was perhaps the greatest turning-point in Géricault's production; at no other time in his career could it have had greater meaning. He came to England at the right moment, and could relate the British to the Continental development; for the English social, industrial, and artistic situation in 1820 pointed to the French situation in 1848. This journey gave him, so to speak, a glimpse into the future, and made him a guide to later generations of painters. During the half century between his visit and the discovery of Turner by the Impressionists Monet and Pissarro, London was the pilgrimage city for artists that Rome had been before.

Only twenty lithographs (pls. 67, 69, 70, 72), perhaps not more than twice as many drawings (pls. 64-66, 68) and water colors (pl. 71), a pair of oil sketches (pl. 73), and one fully executed painting, the *Epsom Derby* (pl. 74), are all that is preserved of one of the most important adventures of the beginning of modern art.

What moved Géricault to return in the spring of 1822 is unknown. Had he perhaps plans to exhibit at the Salon? It would be the first opportunity since the *Medusa,* and the last of his life. But nothing was completed. Instead, we see him embroil himself, during the year that remains to him, in feverish speculation and crazy business affairs. He loses in the stock market, he loses in a project for the manufacture of synthetic gems, and (according to Delacroix) he loses his entire capital shortly before death through an unlucky maneuver in currency exchange. He is forced to sell a great pile of his drawings for bread and butter. At the same time he acts as if he were made of money: he keeps more horses, goes out a great deal, and pays two thousand francs for the mere privilege of having two sketches by Gros copied. In Clément's words, he has been seized by "a confusion hard to define."

Did the state of his health worry him? He had made a poor recovery from the sciatica which had smitten him after an excursion on the Thames; the malady still gave him trouble. A few months after his return to France he had a bad fall. His horse, impatient at a closed gate, tossed Géricault over his head; the rider fell on a heap of stones, felt sharp pain in the spine, but was nevertheless able to get up and go home. The doctor, completely ignoring the spinal injury, recommended exercise for the reduction of an abscess which formed on the left side. Soon afterwards, the unfortunate man had a carriage accident on the road to Fontainebleau; a few days later, when he was taking part in a race on the Champ de Mars, his horse collided so hard with another rider that the abscess opened again.

He decided to spend a few months trying to get well in the house of his

friend Dedreux-Dorcy in the Rue du Helder. This must have been in the late summer of 1822. After a few weeks, he was able to take up his work once more, and the result is a series of twelve lithographs of horses and "a lot of water colors and wash and line drawings." These are undoubtedly designs for the grand projects of the final period. At the end of the year he seems quite recovered, goes back to his atelier on the slope of Montmartre, and resumes work and also his ruinous way of living. He paints the pictures of the mentally ill (pls. 91-94, color pl. IV). But after a few more weeks, the old wound opens, with the worst symptoms. He soon becomes an invalid; after February 1823 he seldom rises from the sickbed. Important physicians are consulted; they explain that it is too late. Clément, on the authority of Géricault's friend and helper Montfort, tells us: "For eleven months he bore steadfastly the clutch of pain and the even more painful operations, until the moment when the growing tumor alongside the spine began to invade the vertebrae." On 16 May 1823 Delacroix notes in his journal: "Géricault came to see me Wednesday. I was touched by his greeting: stupid of me!" From this, some biographers assume that the last illness was of only eight months, or that a temporary improvement allowed going out, and that Clément was not so dependable as is generally believed. This question seems to us of minor importance.

On 26 January 1824 Géricault's life ended at the age of thirty-two. He died in the arms of his friends Dedreux-Dorcy and Colonel Bro; Ary Scheffer fixed the scene in a well-known painting with plenty of sentimentality. The date 26 January is the right one; Chesnau, Charles Blanc, Régamey, and my publication on Géricault's drawings and water colors mistakenly follow the first biographer, Batissier, and give the 18th as the day of death.

No one saw more clearly than the artist himself that he had not fulfilled the promise of all that he might have given from the wealth of his capability and insight. "If I had only made five paintings; but I have done nothing, absolutely nothing!" That is the harsh judgment of a dying man. At the same time, he knew that he could give direction to his generation and his century: he had a mission.

Géricault died even before David and Goya, the two Janus figures of the border between old and modern art, and he fell at once among the forgotten. No one was interested in carrying on his mission, least of all the Romantics and Delacroix, who in the privacy of his diary naturally acknowledged how much he owed to the painter of the *Medusa,* but who in his pride noted it down as "stupid" to have been "touched" by the visit of the only slightly older man.

Just before 1848, with the French political crisis and the dilution of true Romanticism, Géricault appeared again on the field. The romanticization of his life which was now begun by Coquatrix and blown up by Michelet to the dimensions of a political document, can be forgiven and set aside with small loss. On the other hand, real knowledge of his work also began to broaden; and in the light of later developments of style it is interesting to see how the realistic, impressionistic, and constructive elements of form in his art were discovered step by step, understood as guideposts to new development, and suitably appreciated. Gustave Planche gave the signal in his *Portraits d'Artistes* in 1853: he declared that without Géricault French art would have gone to its grave with David. Courbet labeled Géricault, along with Prud'hon and Gros, as a founder of living art, and he praised his contemporary themes no less than his luscious brush-stroke. Seven pictures by Géricault were acquired by the Louvre between 1849 and 1851, the first accessions since the *Medusa,* which had been bought from the posthumous auction sale.

The next rise of a Géricault wave was marked by the appearance in 1867 of Clément's basic monograph, the entry into the Louvre in 1866 of the *Epsom Derby* (in which anticipation of Impressionism was at its strongest), and the creation of the His de la Salle collection of almost a hundred Géricault paintings and drawings, which were scattered over the face of the earth by an auction in 1878. How much Degas and other artists of his generation were moved by these events can be more readily imagined than described. Also the first forgeries of Géricault can be traced to the decade of the 'sixties.

Rosenthal's excellent biography of 1905 had little success, from which we can tell that interest in the painter was again at a low ebb. By contrast, the centenary of his death in 1924 found not only artists drawing inspiration from him, but for the first time a high receptivity among the general public. The great memorial exhibition organized by the Duc de Trévise and Pierre Dubaut, with the impressive number of over three hundred paintings, drawings, and lithographs, marked the beginning of a Géricault renaissance, of which we all are witnesses. Nearly thirty exhibitions, ten books, and countless articles tell of the care taken to account for a misunderstood artist in his many facets and his true dimensions. The author of the *Raft of the Medusa* and the painter of horses widens into an artistic figure of universal interest, possessed in content and form by the very expression of "modernity." Finally, he has been examined from the standpoint of the history of style and of the history of ideas. While it used to be assumed that in the art of the 19th century there was a break at every new generation, it is now apparent that through Géricault

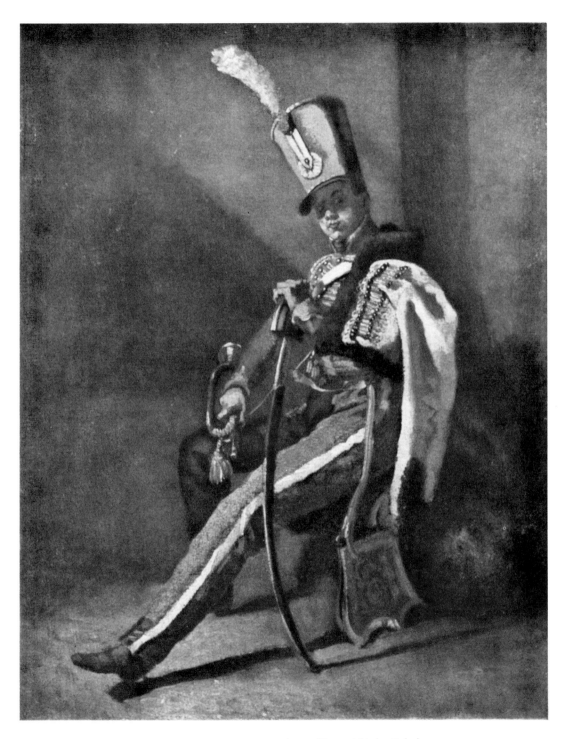

I. Trumpeter of the Hussars. Vienna, Österreichische Galerie

bridges and transitions were created, which led from David and Prud'hon towards Courbet, Manet, and Cézanne. In Géricault, all this is, admittedly, more often intimated than accomplished; for, despite the rediscovery of many first-class pictures of Géricault, his work remains incompletely revealed, and depends upon the help of his admirers for reconstruction.

III. IDEAS AND EXPERIENCE

Géricault's artistic career was limited to the years 1811-1823, a period filled with enormous tension and producing radical changes in all phases of life.

At the beginning of this span of years, Napoleon stood at the height of his power: all that lived and moved and had its being in Europe responded to his decree; the people, in Stendhal's phrase, were "electrified" by him; and by him base and egoistic passions were brought to a standstill (*Mémoires d'un Touriste,* Edition Calmann-Lévy, 1858, vol. I, p. 81). For the generation that had lived through the awakening in revolution of a new idea of humanity, the "people's Emperor" was a symbol of modern progress and, even though he could not be considered a "model" liberal, the liberals were on his side. Their own culture-spreading and civilizing goals were subordinated to the political organization founded on power and order. On this account the France of Napoleon, even in the industrial sphere, did not keep pace with other nations.

All this changed after the fall of the Emperor, when the Restoration imposed the silence of the tomb on all political discussions. It was as if the energies released by the revolution and the Empire were now transferred to other fields, where they induced a modern movement. In art, literature, and philosophy the second fifteen years of the century offered a far more colorful and lively picture than the first fifteen—limited only by the fact that arts and letters could not tamper with political questions. In all domains, the new tendencies had more the character of a push by the avant-garde, of daring and meteoric experiments, than of broadly maturing developments: the political pressure weighed on one and all, and inhibited a general cultural blossoming. The Empire had had fairly broad popular support and had developed a sort of vernacular. The Restoration period can be considered, in all respects except the political, as an open no-man's-land into which everyone was invited to make an excursion or two; indeed it would be hard for him to get a firm footing in it, but on the other hand nobody would hinder his foolhardy sorties.

Géricault was the man with the best eye for observing this unique circumstance. Not only did he notice individual events, but he observed, more instinctively than intellectually, their connections and cross references; and he

set himself the artistic task of assimilating his observations and ideas into the tradition of painting. With his peculiar temperament, there can be no question of his working out a "program" or following a set ideology; rather he would spend his life giving to the artistic form of the painted image a new content, readily taken in by the eye. Until then, such content had been given form in printed illustrations or literary reportage, and associated with rather sloppy principles of composition.

The *Raft of the Medusa* (pl. 45) offers the best example of Géricault's capacity for combination. The point of departure for his interest was a newspaper report, extended by the exhaustive eyewitness portrayal of the catastrophe and its preludes in a book which took the public by storm. Among different possible episodes, the painter's preference fell first on three scenes (pls. 41, 46, 47), then on two, finally on one, which became the subject of the vast painting. Innumerable sketches in oil, pen, and pencil give an insight into the long process of crystallization, while many rather elaborately executed studies of heads and other parts of the body were not used in any of the projects. Quite aside from their artistic value, if all the hundreds of large and small works are brought together and looked at simply as documents of a certain situation in the history of culture, a new world opens.

The documentary curiosity and appetite found in this picture are not absolutely novelties. A generation earlier Louis David, in preparation for his *Oath of the Tennis-Court* and the *Coronation of Napoleon,* had piled up physiognomical studies and single portraits of the participants by the dozen. Géricault started the same way. The central figures of the *Medusa* scene are investigated first as personalities by means of portrait studies. It is known that the artist sought and won the friendship of the two authors, Corréard and Savigny, as soon as he had read the story of the shipwreck. The features of the former, at least, have come down to us in an almost life-size study, and they appear, too, in the finished picture. There is good ground for supposing that the same thing was done for the latter. For other and less important actors in the adventure, Géricault, says Clément (p. 143), used the faces and bodies of his friends Jamar, Delacroix, and Dastier as models.

The figures seen as types are on another level: the gray-headed man who, according to Clément, "did not belong to him," but was taken over ready-made from Gros's Jaffa picture; an Oriental from the episode of the sailors' revolt, for whom he got his inspiration from a painting by Doyen (pl. 49). Even the figure of a man driven to madness by privation is very little individualized. Later, when the artist's interest in the psychopathic was aroused, it

would be different: the world would become specialized and rich and intensely noteworthy for him exactly to the extent to which he took part in, or took sides with, various phenomena. The curious will notice among the shipwrecked three Negroes, who are not the conventional "blackamoors" of the 18th century, but individuals of varying mien; from them we can read the artist's interest in colored people. To be sure, these men were attached to a group which was traveling to Senegal to resume administration of that African colony; and three of them among nineteen survivors would not be excessive. But to Géricault, the problem was the other way around: precisely because the story allowed the inclusion of one or more Negroes, it had a stronger attraction for him, being connected with things and experiences long familiar to him.

The Negro problem had concerned him for years: nothing was better suited to a nature like his. Beginning with the skin-color and the racial type (purely visual characteristics), and going on to the special temperament and a particular sort of vitality, he could present a view of social and political associations which it would have been very difficult to deal with in the abstract. He found in the Negro a concrete symbol through which he could make clear his perspective on the world. He made physiognomical studies of individual colored men and women (pls. 48, 50), and there is a great group of drawings occupied with love scenes among them, including even a rape. The Negro boxer is contrasted with his white opponent (pl. 61). Among the unexecuted late projects was a gigantic fresco which was to have the slave trade for its theme (pls. 86, 87)—a world political problem with which the public opinion and legislation of many countries had long been concerned, and which had been glaringly lit up at the recent Congress of Vienna as a blot on civilization. Unhappily this design did not go beyond a couple of slightly developed drawings, which show wish but not fulfillment. Even this much is important because it shows that Géricault was not working in the tight framework of "art for art's sake," but that he ranged himself with the tradition stemming from Diderot and David, which took the reality of the world, with all its broad concerns, for a field of vision, and did not shirk moral responsibility in a sound-proof ivory tower. Yet he did not become a tendentious painter or pamphleteer; artistic invention and stylistic moulding were not wanting in his work, but were needs that demanded greater discipline of him as his subjects became grander.

Whence came this appeal of the Negro? It would be easy to draw up an iconological pedigree, from Rubens to Gros's *Battle of Aboukir,* which would show that in the past the man with dark skin, or the most exotic of the three Magi, had acquired a right to a place in the picture merely by virtue of his

color. Along with the Negro, there had risen up since the French Revolution the question of his right to self-determination; and, in consequence, the moral and political status of colonies was called in question. The revolutions in Haiti led by Toussaint L'Ouverture and Dessalines had stretched over the decade 1796-1806; the second in particular had shown in its scenery, its power, and its contrasts all the elements proper to a "modern" socio-political drama: the Negro ex-slave sets the stage for a revolt, drives out the French overlords, proclaims himself emperor, commands a massacre of all whites, and in his turn falls victim, at forty-eight, to political assassination. This story and its setting cannot have been unknown to Géricault: his friend Colonel Bro had been for three years a member of the expedition to Santo Domingo, and had probably talked about it in Horace Vernet's studio with as much flair for the dramatic as he afterwards showed in writing it down (*Mémoires du Général Bro,* 1914, pp. 1-26). Is it too far-fetched to assume that this was a strong stimulus to the painter, and that the intended monumental painting of the slave trade would have been only the beginning of a series having for subject the misery and the splendor of the dark race?

The idea of serial representation, or rather of picture-series, had occurred to Géricault several times. As we have mentioned, there exist among the preparations for the *Raft of the Medusa* three subscenes: the mutiny (pls. 46, 47), life on the raft (identical with the executed painting), and the reception of the survivors aboard the rescue ship (pl. 41). These are indeed successive episodes, but not to be considered as a set or series, for they served the artist only in his search after the most fruitful moment for representation; he dropped the rejected designs at once.

Another group of picture-suggesting formulations is found in the four illustrations which Géricault made for the fourth edition of Corréard's *Medusa* book in 1821, two years after the painting. We see the sinking ship, the raft, the reception of the rescued by the African king Zaïde, and a scene in which English officers visit Corréard in hospital. Here again we are dealing with illustrations to separate chapters; they have no inner or organic unity, only an outer connection of a literary sort.

It is quite otherwise with the *Fualdès Story* (pls. 54-59), which is conceived as a genuinely self-explanatory and self-contained series. Its impetus came, as in the case of the *Medusa,* from a contemporary scandal, which kept Europe breathless and which involved two notorious trials and two books, more widely read than the reports of the trials (Fualdès, *Histoire du Procès Instruit,* 1817;

Mémoires de Madame Manson, 7th [!] edition, 1818; same, English translation, London, 1818).

In the small deep-southern provincial city of Rodez, a pensioned civil servant named Fualdès was lured one evening into a brothel and murdered in a subtly bestial manner: his blood was licked up, to the last drop, by a hog which had been kept in readiness, and his body was tossed into a river. Excited comment said: Is the motive political revenge against an old liberal and revolutionary partisan? Is it just a murder incidental to robbery? Or is this a sexual crime? The affair was complex, a "natural" for exposing the structure of contemporary society in its various stratifications, tensions, and passions. It is no wonder that Géricault scented raw material that invited him—even more loudly than the *Medusa* catastrophe—to hold forth on the moral climate of the day. But material and form are not separate problems for him: they grow out of one another. The replacement of a possibly oversized painting by a string of episodes following one another in inherently logical order—this would have opened great possibilities, and avoided many of the later difficulties of Realism.

Géricault broke off the experiment prematurely, leaving us barely able to guess at his plans. The series of five or six drawings goes little beyond what was accomplished in the pictorial broadsides of his own day, or in the block-books of the late Middle Ages, with their representations of the *Life of the Virgin* or the *Dance of Death*. The result is not therefore startling to look at; what does surpass the traditional framed picture is the intensity to which the artist works up in his search for modernity in the theme and (hand in hand with this) for a new dynamism in the language of form. Over against the life-sized figures in the gigantic format of the *Medusa,* we now see a multiplication of scenes in the Fualdès cycle. It is as if he had sought to integrate the monumental frescoes of the Renaissance and Baroque with the serial method of intimate graphic art, and so to reach a new pitch of expression.

In face of the difficulty of getting a clearer view of the painter's intention from the various fragmentary plans and designs, this point seems to us of central importance. The question is: does Géricault's strong inclination for compositional ideas and (as will be shown) even stylistic elements borrowed from earlier epochs merely point to eclecticism, or does it reveal an instinct for the essence of artistic inspiration, a knowledge that an original integration of inherited elements will go farther than an attempt to start from scratch? The whole problem of tradition is stated here with urgency at a turning-point in time: how to separate fruitful and useful tradition on the one hand from

sterile imitation on the other? As is so often the case with Géricault, the answer is indicated rather than expressly uttered. The great pictures, "flung onto the walls with buckets full of color, and brooms for brushes," in which the "epic of the modern world" was to be mirrored—these existed only in the wishful thinking of the dying artist, and their main lines can be reconstructed only from a few vague pencil drawings. How conscious the painter was of their groping and experimental character can be seen in the fact that he set aside the Fualdès designs at once when the popular Paris broadsides took up the same theme. Pierre-Louis Duchartre and René Saunier (in *L'Imagerie Parisienne,* 1944) catalogue two different picture-series on the Fualdès affair (each in four scenes, one published 1817/18 by Bulla, the other in 1818 by Noël). According to Clément, Géricault said they were better than his drawings, and he abandoned his project. It is interesting, in this connection, to see that Goya (following in the path of Hogarth) had made a similar advance in the painting of serial subjects. The story of the bandit Margato, who is captured by a valiant monk, likewise deals with a topic of the moment in newsreel fashion, and in six episodes (reproduced in A. L. Mayer's monograph on Goya and in the Art Institute of Chicago's catalogue, *The Art of Goya,* 1941, pp. 46-49).

In taking the trouble to bring a contemporary and even ephemeral subject into his painting, Géricault was not unconsciously treading in the territory of popular picture-books and broadsides, with their naïve fantasy. It was no accident that he took up the problem of narrative form achieved by purely visual means, or that of the optimum size for a given picture. In this respect he was a lonely forerunner. From Courbet to Picasso's *Guernica,* these three groupings of problems and their changing mutual relationships have marked the pulse-beat of changing style: a) the influence of broadsides on Realism (see Meyer Schapiro, "Courbet and Popular Imagery" in *Journal of the Warburg and Courtauld Institutes,* vol. IV, Nos. 3-4, London, 1941); b) the dominance of perceptual immediacy in Impressionism; c) the anti-realistic imagination in modern art.

Besides the *Medusa,* the Negro question, and the Fualdès cycle, there are two other political themes which involve religious and national freedom. A single drawing (pl. 85) relates to the *Liberation of Victims of the Inquisition;* Clément assures us that it is the design for one of the unexecuted late pictures of huge size, and thus it gains a special interest. The date, 1823, coincides with the foray into Spain of the Duc d'Angoulême, who set aside the Constitution and restored the absolute monarchy. Géricault recalls in this sketch another Spanish expedition, when Napoleon was in the role of the emancipator, open-

ing the centuries-old prisons of the Inquisition. How the situation had changed in fifteen years! Could the artist possibly let slip this opportunity to contrast the liberalism of the Corsican (in which he believed) with the currently regnant reaction of the Bourbons?

The scene itself offers a parallel, within the climate of human excitement, to the *Medusa*: after the hardships and uncertainties of an existence without life or scope, the door opens to freedom. A whole gamut of passions shows itself in the gestures of the confronted families, from speechless astonishment and disbelief to wild enthusiasm. We see men, women, and children of all classes and races, bound together by nothing but their liberation at the same hour from chains that have held them subject to an antiquated system of power. It is instructive to see how Géricault, towards the end of his artistic career, visualizes such a scene under the aspect of sculptural figure-groups in the spirit of the Renaissance and its tradition of order in space—and this somewhat differently from Goya, who at the same date would have drawn from such a motif a demonic and lightning-like tension between darkness and daylight. This circumstance should not have been overlooked by those critics who wish to keep the painter of the *Medusa* altogether on the side of Romanticism.

A further argument to this effect is offered by Géricault's religious position, which must be called indifferent if not negative. In such a picture as the *Liberation of Victims of the Inquisition,* at any rate, he gives no hint at the "religious" content, and in his whole work there is no trace of interest in religious problems or a religious atmosphere. A study and a drawing of the *Entombment of Christ* are merely formal variations on old masters; the *Prayer to the Madonna* (pl. 21) is likewise a formalized report on a Roman street scene, devoid of any effort to bespeak religious empathy. It is known that the painter declined one of the very few commissions he ever received, given him as a sop by the government because it had not bought the *Medusa*: the commission was for a Madonna. This was the first time in which something more than religious disinterestedness showed itself in an artist: namely, the philosophical-political tension between liberalism and clericalism, which came later to drastic expression in Courbet.

The idea of national independence had spread in the decades since the Revolution and taken form in many quarters, but only the war for Greek independence allowed the world's heart to beat faster. Lord Byron's participation from 1823 to his untimely death in 1824 made a link from the arts and literature to daily events, which could not have been more forcefully devised: a live poet and a hero to boot, who turned his sensitivity and passion, his conviction

and determination, to verifiable warlike deeds, who himself lived the lives of the heroes he had created—all this showed that a legend could be flesh and blood; it led to the resurrection of the fascinating idealized form of Napoleon a year after his bodily death; it was a signal for the awakening of a Europe which the Bourbons had lulled to somnolence.

Géricault's last lithographs (D. 94-97)* are illustrations to the works of Byron in the first French edition; *Mazeppa, The Giaour, The Bride of Abydos,* and *Lara* are all subjects which were lithographed (with the help of Eugène Lami) in the feverish unrest of the last months of illness; they won no artistic renown. But they are remarkable as witnesses to the artist's flair for advancing into the midst of situations which in the future would prove provocative to artists; he made this connection with the Byronic world apparently before the first translation was printed, and long before the "adoption" of Byron by such painters as Horace Vernet, Louis Boulanger, and Delacroix, or such poets as Victor Hugo. *The Giaour* especially anticipates the whole "Oriental" local color of the Greek-Turkish war. Besides his interest in Negroes, Géricault had a strong leaning to Oriental physiognomies (pl. 33): his servant Mustapha, the model for many studies, was a Turk, and one of his most beautiful water colors of the last period shows the march of the Turkish army along the sea (pl. 79). Nevertheless, only one of his paintings derives from the Greek struggle for freedom (pl. 78), a somewhat unclear episode of refugees or plague-stricken people swathed, this time, in Goya-like shadows. Clément is not quite sure what to call the scene, which in any case has nothing that would fit it to serve as a monumental panorama of the modern world.

Most of the projects discussed above belong to the final period in Paris. The artist's "social" eye doubtless had grown vastly sharper during the two immediately preceding years in England. There he had had glimpses of the future, and seen a world which, with its industrial production and its social contrasts, ran a whole generation ahead of conditions in his fatherland. A famous description of the British situation was written by Friedrich Engels in the first volume of his *The Development of Socialism* (German edition, Zürich, 1882): "Steam and modern machinery changed manufacture into modern heavy industry, and therewith revolutionized the whole basis of bourgeois society. The drowsy growth of the period of 'manufactures' changed to a real 'storm and stress' period of production. With ever growing speed the separation of society into great capitalists and propertyless proletarians moved to

*D. and following numbers refer to the critical catalogue of Géricault's graphic work by Loys Delteil: *Théodore Géricault,* 1924, in the series *Le Peintre-Graveur Illustré.*

completion; between them, instead of the former stable middle class, a shifting mass of artisans and retail merchants now led a precarious existence. Already the new method of production bred crying social abuses: the squeezing together of a homeless population in the worst dwellings of great cities—dissolution of all the inherited ties of regional origin, patriarchal organization, and family—overworking, especially of women and children, to a horrifying degree—massive demoralization of a laboring class which was thrown suddenly into new conditions, from country to city, from farming to industry, from settled ways to uncertain conditions of life which changed from day to day."

Géricault was so influenced by these circumstances that, more than in any other period, he surrendered to the enticements of subject matter and occasionally even set aside the discipline of controlling form. He found an excuse in the "inconceivable rage" (letter to Dedreux-Dorcy, 12 February 1821) for lithography, in following which he believed he could make easy money and at the same time attract the attention of true art-lovers. He let himself be moved to tears by the sentimental pose of a figure in one of Wilkie's paintings, and asked indulgence for his Anglomania (letter to Vernet, 1 May 1821). This is probably enough to show how ready and how glad he was to build himself into his new surroundings, even if the painted work of this period shows little of that feeling. Clément's catalogue actually lists only horse-pictures, and even among the drawings he mentions only three exceptions (Nos. 140, 141, 157). But the horses themselves are informative because of the way in which the artist brings them into the social process of work: plowing (pl. 71), hauling coal (pl. 75), on the wharves (pl. 72), and at the races (pls. 73, 74). They always appear in connection with human beings and in contemporary aspects. "In England," writes Friedrich Antal, "he does not utilize scenes of contemporary life, as in Italy, merely as a starting point for classical scenes; he now regards them as ends in themselves" (*Burlington Magazine,* January, 1941, p. 14). It was there, in the England of Hogarth and Rowlandson, that Géricault freed everyday subjects from their connection with "common" prints, lent them the tension and grandeur that had fallen to him from the classic inheritance, and exalted them to the level of the most progressive pictorial form.

Some of the English works, especially lithographs, bring social contrasts out strongly. The *Paralytic Woman* (pl. 70) in her pitiful armchair, a victim and a castoff of economic conditions, is the central point and in a way the heroine of a street scene rounded out by a comfortable mother and child on

one side and the carriage of a rich man on the other. And no sharper opposition could be thought of than that of another lithograph (pl. 67), where an exhausted beggar sits by the show window of a bakery, while a lady and a busy wagon are seen against a background of wharves and factories. Nor is it any different in the *Fishmonger* drawing (pl. 65), where the sleeping merchant, the teasing children, and the approaching customer bring almost dramatic elements into a standard market-day episode. We must compare this entirely autographic drawing with the lithograph (D. 24) in which Charlet took a large part, to see how Géricault not only tightens and clarifies the composition by simplifying, but also polarizes the situation itself into contrasting groups. A merely amusing and not very pertinent figure, like the woman with a basket on her head, is eliminated, and instead of her there appears in the foreground a small child whose motion is tied to that of the dog so as to concentrate the scene in a ring-shaped focus. Nowhere does the difference come clearer than here between the pedestrian, merely anecdotal illustration and the artist's new concept. Even in so rapid a sketch as the *Hanging* (pl. 68), the three condemned men, sure enough, are contrasted to the hangman; the officiating parson, representative of another class, is not omitted, and finally a few strokes in the background indicate the wastes of the industrial landscape.

Most of the elements which come to the fore in the artist's English period may be found present at an earlier time. He had represented landscapes as well as dogs, horses, children, soldiers, workmen, spectators, grooms, and even the disinherited in the dusk. What had heretofore occurred in bits and pieces, however, was now united in living concord, and it is no accident that, aside from stylistic changes, almost every work now contained a combination of at least three of these factors. The experience of England, with its more fully developed social structure, caused no break in the artist's ideas, but rather gave him a welcome opportunity to integrate his earlier interests and to sharpen them. This could not have been more effectively done than at this time, just after the cutting of the great cross-section through history, eternity, need, and fate which the *Medusa* had intended.

It is significant that these inclinations can be followed right back to the painter's earliest period, and thereby can be associated immediately with David, who ruled French art until 1815. The creator of the *Market Women,* the *Marat,* and the *Oath of the Tennis Court* must be recognized, contrary to the common assumption, as more closely related to Géricault than Delacroix was, or even Gros. Géricault, in his uncomplicated directness, noticeably brought this circumstance to expression by interrupting his stay in London to visit the

master in exile in Brussels (Oprescu, p. 132). Géricault was honoring the liberal, the pioneer of contemporary subject-matter, and the artist. What attracted him in Gros, on the other hand, was the *painter*, the rich palette, the glowing surfaces, the fascinating details. David's influence was lasting and of general character; Gros's effect was limited in time and in extent. Both may be detected in work dating from before the Italian journey. The *Chasseur Officer on Horseback Charging* (pl. 2) is simply unthinkable without proto-types by Gros—for example, the *Battle of Aboukir;* at the Salon of 1812 the jury hung Géricault's picture as a pendant to Gros's equestrian portrait of Murat (see *Gros, Ses Amis, Ses Élèves,* catalogue of an exhibition at the Petit Palais, Paris, 1936, No. 61). The similarity in many traits, the construction, the twist of the body, the tiger skin, the mane of the horse,—and, above all, in the relation of these to the background and the enclosure, —is astonishing. Never-theless, this tangency does not last long, and the reveling in unmodified color is over for Géricault as soon as his pleasure in the bald show-piece, however full it might be of verve.

The urge towards significance played a weighty role with him from the beginning, certainly not for the sake of following a literary, psychological, so-cial, or otherwise non-artistic will-o'-the-wisp, but for the sake of fulfilling his work from within. If many of his pictures seem to be devoted, one by one, to the study of the harmonies of form and color, taken together they are stages between the already formed images and the as yet unformed and desired ones having "meaning." In this respect David was his teacher and example, Na-poleon his guiding star and his standard. His contemporaries and critics saw in the *Wounded Cuirassier* (pl. 8) an echo of the retreat from Russia. "Souls were full of terror and pity. Géricault expressed this universal sentiment in his picture, and especially in the pathetic figure." Naturally, "the painter in Géri-cault outweighed the thinker"; nevertheless "he painted here a representation of unhappy glory" (Clément, p. 65).

The glory and misery of the Napoleonic soldier became one of the prime motifs in Géricault's art, surviving even the impressive experiences in Italy and England; it showed itself again in a group of lithographs of 1823, which again had military subjects (D. 62-64, 66). In 1822 he undertook two illustra-tions for Antoine-Vincent Arnault's famous *Vie politique et militaire de Na-poléon,* the author being an uncle of his friend Bro and one of the principal fomenters of the Napoleonic mythos. The splendid lithograph *Mounted Artil-lery,* dated 1819, is of the same class. The longer in time he was removed from the catastrophe, the more the heroic, positive features of the great but vanished

period came to the fore. Even such comparatively recent misery as that of the retreat from Russia (late 1812) is expressed strongly and in proud and grandiose fashion. The lithograph of the *Retreat* (D. 13), dated 1818, mirrors the fate of the common soldier: "In the midst of the frozen plain a one-armed grenadier moves forward, dragging by the bridle the exhausted horse of a blinded cuirassier who has his left arm in a sling. A half-dead dog trails them. In the background to the right we see an infantryman taking a comrade on his back. . . . Géricault, in exaltation of mood and in poetic-dramatic attack, probably never did anything stronger or more nearly perfect" (Clément, pp. 213 ff.). The same year saw production of the print *Stake-Cart with Wounded* (D. 11), a lamentable huddle of wounded, amputees, and exhausted, hungry, collapsing nags. Decades later the painter Paul Huet gave his opinion in a letter that this work, along with Charlet's *The Old Guard Dies* and Vernet's military scenes, had made the deepest of impressions on his generation (Courthion, p. 164).

The other works (pls. 14, 15) which vary these same themes are of earlier date, probably as early as 1814 and surely before 1816, the year of the departure for Italy; they stand as evidence of the depth and permanence of the shock which the Napoleonic tragedy gave the artist. The water color (pl. 15) is, to be sure, not a study for a lithograph, but it shows related types; personal reports from returning men probably were the bases for such motifs which, later, were turned to this use and that, as was the case with the *Raft of the Medusa* and the *Race of Riderless Horses*. Many intermediate steps are evidently no longer known to us. Even looser is the connection in the case of the *Wagonload of Wounded* (pl. 14), which has no points of comparison with the later lithograph, except for a colorful jumble of soldiers. The wagon is reversed, the heavy body of the wounded man is dragged lengthwise as if in a Caravaggesque *Entombment,* and the whole event is seen in three layers of relief, achieving thereby a monumental simplicity which is surprising even in Géricault. From the viewpoint of motive, it is interesting to see how the figures are stratified: the two active, standing ones to the left; the quiet, seated ones to the right; and between them the group which shows the lifting of the wounded man. Perhaps the germ is present here, in principle, of the visually meaningful separation which we can see in its full flower in the English period.

Only once is there an essay towards a really panoramic view of the Russian tragedy, in a fairly large oil study representing the *Retreat* (pl. 16), which was discovered by that great Géricault connoisseur the Duc de Trévise, and which

recently passed into an American collection. Innumerable soldiers, entangled in an incomprehensible tumult of cannon, wagons, and horses, fill the plain as far as the eye can see. From the groups of tired men in the foreground to the layers of smoke and gloomy clouds on the horizon, the beaten army flows like a stream of lava. A grandiose vision which, in its fragmentary sketchiness, seems more gripping to us moderns than it must have to the painter, who apparently let the project lie in this early stage, and never took it up again. We can easily imagine its execution in enormous size with "buckets of paint," opening a series on the great themes of the time, just as the painter on his sickbed dreamed of them. And here, in connection with Napoleon's fate, comes the first sign of another thing which becomes one of the leading motifs of Géricault's art: the belief that the human drama of modern times must be given visual form through social events as vehicles. Herein Géricault becomes an early guide to the theory of Naturalism and to its grasp of life.

Between this ingenious design and the first and only large full-dress painted composition, something quite novel enters the work of the painter; the stay in Rome and the group of pictures surrounding the theme of racing wild horses on the Corso seem to have distracted him from the illustrating of contemporary history. The greatness of the Roman works is not measured by the importance of their subjects but by the pregnancy of their form. Here the classic masters, with their demand for clear form and balanced composition, have become his instructors. For recognition of this, nothing is more illuminating than comparison of the *Race* in its early version (pl. 27) with the "end-product," the pictures in the Louvre and at Rouen (pls. 28, 29): the former is a sharply observed momentary event with almost impressionistically abbreviated notations of detail (pl. 26); the latter are selections or essences, with the grouping clarified, timeless, and classic; the naturalistic scene seems to be only raw material for the final version of the picture. Looking at the artist's lifework as a whole, but especially at the *Raft of the Medusa* and products of the following period, one might well ask whether this sort of stylization was a detour or even a dead-end street. By no means: discipline through form was of the greatest importance for Géricault's violent character, and without it he would possibly have become a Realist of the calibre of his friend Horace Vernet or Schnetz, Léopold Robert, and Charlet. However admirable many of the pictures of his early period may be, it was only during his stay in Italy that he found his full artistic stature and a measure of self-control which allowed him to advance ahead of his time. It is as if he were able henceforth to move on two planes at once, one where everything was

crystallizing towards definitive form, the other where the new meaningful content came to the fore. Yet these are not treated as if separate; for in truth Géricault owed his greatness neither solely to the new importance of his themes nor to the fulfillment of his form, but much more to the unique inter-penetration of the two.

At this point we must discuss another cluster of subjects which speak of and from a different world: the portraits of the insane (pls. 91-94; color pl. IV). (These works alone would make Géricault one of the foremost painters of the century.) Not that portraits lay absolutely outside his interests; but, in comparison with his contemporaries who brought portrait-painting to a high point at the beginning of the century—from David, Prud'hon, and Ingres to Goya and Lawrence—Géricault showed a certain lack of craving for con-quest in the field of physiognomy. His earlier portraits almost always have members of his circle of friends for subjects, persons whose traits were well known to him; psychological probing is less important than a decorative pic-turesqueness of the still-life type. Therefore children (pls. 60, 81) become de-sirable sitters, and anecdotal "paintable" attributes, such as a dog, a sabre, or a cat, are found; therefore Madame Bro (pl. 80) in her white dress is set off against the red cashmere shawl hung over the back of her chair; and so the veteran (pl. 13) is swathed in his greatcoat and decked with his tall cap. Except for the *Head of a Soldier* (pl. 35), the faces take up only a small area of the canvas, and the characterization comes from the surroundings of acces-sories, from the outside in. This principle seems to be common to the portraits of Géricault's first four periods—however much the stylistic peculiarities of those periods also appear. So the change in the last period, from which the portraits of the insane date, is all the more surprising.

Géricault's relations to medicine and medical men go back at least to 1818, when he was preparing the *Medusa* and, to facilitate work on the immense canvas, rented a studio a few steps from the Hôpital Beaujon. "There he could follow with burning curiosity all the phases of illness, from the first symptoms to the death-agony, and the marks that suffering stamps upon the body. There he found models who did not need make-up in order to portray all the nuances of physical suffering and spiritual anguish: the ravages of illness and the terrors of death. He had an arrangement with the internes and nurses, who provided him with cadavers and amputated limbs" (Clément, pp. 130 ff.). The studies of arms, legs, and heads (pls. 51-53, color pl. III), in their pitiless naturalism, give an idea of this activity, which went on partly in the hospital and partly in the atelier. To the same period belongs the friendship with

Savigny, one of the chief witnesses of the *Medusa* catastrophe and an author of the report on it; he was a physician, and must have aroused or strengthened the medical flair in Géricault. Who knows whether he may not have given the impetus to add, alongside the suffering, dying, and dead on the *Raft of the Medusa,* the deranged man who can be seen in the center, right below the mast?

It is not easy to decide whether the stay in England gave new stimulus to the theme of art-and-the-mentally-ill. Hogarth's engraved series, *The Rake's Progress,* puts the hero at one stage into an asylum, the old Bedlam; between 1758 and 1801 at least six scientific inquiries into the nature of mental illness appeared in London (see Gregory Zilboorg, *A History of Medical Psychology,* New York, 1941), and they pointed to the immediacy of this complex of problems. But the viewpoint of these inquiries is quite different from Géricault's. The fact that Magnasco had already painted scenes including people of abnormal mentality, and that Goya had studied cases of demonic possession in the asylum at Saragossa, can hardly have had any effect on our artist. Rather had he been impressed by Gros's *Napoleon Visiting the Pesthouse at Jaffa,* in which mental patients were shown receiving—according to the custom of the time—the same treatment or lack of treatment as the victims of epidemics. When Géricault set up his easel in the Salpêtrière in Paris on invitation of the resident psychiatrist, he painted (contrary to all his predecessors) no vast scene, no life-and-doings of the inmates, but the ten classic type-cases of Dr. Georget, ten individual studies of sick people. Only five of the pictures are now preserved and well documented, while all attempts to find the missing ones have been thus far unsuccessful. In this connection the following possibilities have been mentioned: 1) *Old Woman,* formerly Vienna, Eissler collection, accepted by Paul Fechter (*Kunst und Künstler,* XI, 1913, p. 273), by Hans Tietze (*L'Amour de l'Art,* 1925, p. 179), by Cadinouche (*La Médecine dans l'Œuvre de Géricault,* dissertation, Paris, 1929, p. 34), and by Walter Friedländer (*Neuphilologische Handbibliothek,* vol. 8, Bielefeld, 1930, p. 116); 2) *Young Man,* Northampton, Massachusetts, Smith College Museum; 3) *The Vagabond,* New York, H. P. Hill collection, accepted by the Duc de Trévise and Robert Lebel; 4) *Man from the Vendée,* Louvre (pl. 90), published by R. D. Solonge (*Bulletin des Musées de France,* X, No. 4, 1938). Only the two last can in my opinion be recognized without hesitation as genuine Géricaults, if not as portraits of the insane.

Ever since the Middle Ages, and especially in the ideology of the Inquisition, the insane had been viewed as possessed by the Devil, guilty creatures

scourged of God. Only the dawn of humane ideas with the spread of the Enlightenment and of the Industrial Revolution led the way to the creation of psychiatry, and with it an interest in the observation of clinical cases. The French Revolution, as helper of the humble and injured, recognized the right of all the sick to treatment. Dr. Pinel, a contemporary of David, unchained his mental patients and treated them as friends who needed his counsel. Dr. Georget followed this new tradition. As one of the founders of social psychiatry, he went before the courts, at trials of insane criminals, to plead extenuating circumstances and ask for competent treatment. His importance has been set forth in an admirable essay (Margaret Miller, "Géricault's Paintings of the Insane," in *Journal of the Warburg and Courtauld Institutes,* vol. IV, Nos. 3-4, pp. 150-163), from which the following sentences are quoted: "The publication of his book, *De la Folie,* in 1820, established him at the age of twenty-five as one of the authorities on mental diseases, and the next year it was followed by a study on the physiology of the nervous system and the brain, written in two months; a tour de force which surprised the profession as much as his native 'liberté d'esprit presque sauvage.' . . . When *Le Nouveau Dictionnaire de la Médecine* was planned . . . he was given most of the articles on mental and nervous diseases to write. . . . In his *Physiologie des Systèmes Nerveux* in 1821 Georget had denied the existence of an immaterial power in or outside of man. . . . This materialistic view . . . was attacked with a bitterness and intensity which approached persecution. . . . Madness is considered by Georget as a particularly modern dilemma, dependent largely upon progressive social developments. . . . It is not considered as an indication of social or racial decadence, but the cruel exaction of the most energetic and progressive human activities. 'Thus insanity is particularly common in free countries, among people troubled by factions and parties, subject to violent political commotions which upset all elements of society, and to revolutions which compromise everyone's interests . . . in regions that are ravaged by repeated wars, in enlightened, busy, businesslike nations; in a word, this malady is born and grows under circumstances which also demand concentration, activate the wits, and involve all the passions of mankind.'" (These last sentences are taken by Miss Miller from Dr. Georget's article *Folie,* in the *Nouveau Dictionnaire de la Médecine,* Paris, 1832.)

The man of the future, perceived under the aspect of his neuroses and psychoses—that would be a highly interesting result of the collaboration of Géricault and Dr. Georget. Whether such an exchange of ideas ever took place, and under what conditions, we cannot tell from the material that has

II. Horse Market. Paris, Louvre

come down to us. Margaret Miller, however, is surely on the right track in her conclusion (p. 160): "By conceiving of Georget's patients not only as case histories, but as individual personalities, Géricault was able to transfigure physiognomic documents required for an alienist's archives into discerning portraits and thus to synthesize both the objective observation and the generous human insight which, through the science of psychiatry, had effected such a change in the lives of hundreds of hapless French citizens between the Revolution and the Restoration."

This transformation into penetrating psychological portraits can be no better explained than by saying it is Géricault's secret; no other artist of that epoch has achieved anything similar. He avoided the obvious danger of making caricatures, evidently taking more lightly than Georget the "organic orientation" of the mentally ill—the theory that mental and spiritual defects must show in the facial traits is no longer accepted. That he saw his sitters primarily as suffering human beings, and so rendered their expressions, is a striking end to a lifework compressed into only twelve years, an end that is also a promise.

Let us be very conscious of the fact that this life, cut off at thirty-two years, was—however full—yet fragmentary.

IV. The Formation of a Style

However much we may be interested by Géricault's life and by his times and his feeling for them, it is primarily the artistic power of his work that makes him an important personality for us. It is crucial for just judgment of an artist that we know his point of departure. What are the achievements of the previous generation of artists, and what is the novice's relation to the "ancestors"? Does he feel called to preserve a tradition, to revise it a little, or to make a clean break with accustomed theory and practice? Where does the new call lead him? Where do his helpers and sympathizers spring from?

In Géricault's case the point of departure is clear enough if we take 1810 as the beginning of his real career. He was nineteen years old, had left Carle Vernet's studio after two years' study, and entered the famous atelier of Guérin. His new master, to be sure, never was a disciple of David; but, though he was a second-rate painter, he was not inferior to David as a teacher, and he held closely to David's theories.

Now, what was this school of David to which, over the years from 1780 to 1816, 295 young artists not alone willingly but proudly belonged, and whose reign was almost unchallenged? After the master's exile, after the destruction

by Romanticism of the notion of a continuing body of practical art pedagogy, this school was so discredited that it is hard even now to form an unprejudiced idea of it. Delécluze, who was for decades a respected critic and who had been in youth a student of David, had a long enough perspective to write at the end of his life *Louis David, son école et son temps* (Paris, 1855). In this book, now nearly forgotten, he gives an apologetic but not uncritical account. David, says he, initiated a reform which was remarkable for a happy union of study from nature with exercise after the antique (p. 399). The dauby excesses of a retarded *style rocaille* and the sterile formulas of the old academy were put to rout by a theory of ideal beauty whose effect was most powerful in harmonious compositions based on linear design. Through several approaches and variations in style the talent of the artist matured steadily: "the *Horatii*, the *Death of Socrates, Marat*, the *Sabine Women*, and the *Coronation of Napoleon* are the important stages on David's upward way" (p. 401). Of the last he says: "If the subject has not allowed David to disclose the same artistic qualities as the *Rape of the Sabine Women*, yet the style is both splendid and simple, the general effect beautiful, the coloring truthful, and the center of the composition, from the Emperor and the Empress to the Pope and his surrounding prelates, is of such superior handling that it is fair to credit David with uniting here all the good qualities which in earler works he had shown only piecemeal." Though only two of these chief works dealt with contemporary events, such subjects were as welcome to David as "historic themes," so long as he could express an artistic unity.

According to Delécluze, both Napoleon's personal taste and the government's influence called for pictorial celebration of recent and current military success and put this sort of painting in a special class. The great decennial State contest of 1810, which was preceded by a pompous campaign of announcements, offered prizes in two classes: 1) historical painting; 2) painting devoted to "themes honorable to the national character." All artists had to reconcile themselves to this scheme and—if they cared to make a name for themselves—had to practice a way of painting "in which the imitation of military accoutrements was more and more emphasized, so that a body of anecdotal painting arose which soon swamped everyone" (Delécluze, p. 320). David took first place with the *Sabine Women* and the *Coronation;* but his pupil Girodet-Trioson, with an historic subject, was ranked next along with the "contemporary" Gros. *Napoleon Visiting the Pesthouse at Jaffa*, the *Battle of Eylau*, and the *Battle of Aboukir*, still impressive works of Gros in our eyes, were naturally favored by the administration. The jury felt that form was as im-

portant as subject, and rendered a report which was thought equivocal; when pressed by the government about prizes, they begged the question of categories and gave no second prize at all.

This is the sort of scene, then, upon which Géricault enters. On one hand is the Davidian "party line," tough in its discipline of drawing, credited with a few great pictures and discredited by the gradual decline of its creative power (even Delécluze calls the *Investiture of the Eagles* a failure); on the other hand stands Gros, at thirty-nine in the heyday of his powers, creator of the monumental Napoleonic image, a bit shaky perhaps in composition but, as Delacroix was to remark later on, transcendent in "the poetry of details."

Géricault's reaction to all this was characteristic. He learned from Guérin, but felt a need to go beyond what he had learned; he had mastered line, and must stretch toward a realization of the sculptor-like and the massive. His search brought him to the antique sarcophagi in the Louvre and to many other works having a sort of kinship to them. He developed, meanwhile, the plans for his first major picture, which brought him close to Gros. These operations on three levels occupied his first period of six years, half of his whole career.

He notes down certain figures and groups from the sarcophagi, choosing those whose construction in planes gives the essence of a position—sitting, riding astride, or bracing the legs like a charioteer—or such harmonious arrangements as the people around a sacrificial altar. While the plastic content is especially brought out in these drawings, and emphasized at the shoulders and other articulations by pen hatching in the style of classic Renaissance line-work, there are other sheets in which a more dynamic character is expressed by strong diagonals and dramatic contrasts of light and shade—in other words, drawings which emphasize the painter-like, almost baroque qualities of late Greco-Roman work. In this tension and reconciliation between antipodal possibilities the mature Géricault already shows himself. He had a stylistic forerunner in Poussin, who schooled himself by drawing antique reliefs of the late period, and whose compositions often unite a layered division of space with animated diagonals.

The sarcophagi, with their late-classical baroque, their plasticity, their space-making chiaroscuro, are a key to the artist's ecumenical taste. It looks at first sight as if he had appropriated indiscriminately whatever he wanted to copy at the Louvre: all styles, all periods, all regions. Closer inspection shows him to have chosen carefully, for between the sarcophagi and the paintings which he copied there is a connection: he tested the painters for their illusion of relief. This correspondence has been little noticed, if at all. For Raphael,

Giulio Romano (fig. 2), Titian, Van Dyck (fig. 1), Paolo Veronese, Prud'hon, even Velasquez show, in the examples he chose, a clear relief-like stratification in depth. Rubens, too, he copied only in such works as held to a layer-like arrangement of space (*Deposition from the Cross, Venus Detaining Mars, Maria de' Medici on Horseback*). Throughout his later changes, Géricault remembered this principle, which unites the *Race of Riderless Horses* (pls. 26-29) to the *Epsom Derby,* otherwise worlds away (pl. 74), and to the late *March of the Turkish Army* (pl. 79).

Admittedly the study of antique sculpture was nothing new. The "School" had a high opinion of it, but they worked from plaster casts or from the numerous engravings after famous statues, which were thus already abstracted into a linear, two-dimensional style. Only in 1808 did the transfer of the Borghese collection to the Musée Napoléon open a vision of the antique that was new in France—namely, the sarcophagi in high relief. Géricault can be differentiated from his predecessors in the school not only by his having been able to work entirely from originals, but also by his having studied groups of figures. The common Davidian precept, to form oneself "on Nature and the Antique," was taken as seriously as a law by the young man—a law observed, under the heading of Nature, as it was not always observed in the academies, where it was often easier not to bother to look out the window. Géricault studied the antique but he never turned his back on nature: there is no figure in his work which he made up out of his head. Every sword-grip, every horse's hoof, every action of a boxer, every turn of a body, is seized in its function and meaning, and fixed in innumerable rapid studies (figs. 3-5). There is no more "naturalistic" observer, no more devoted researcher of phenomena. Nor could anything be easier than to marshal piles of drawings which would show that he was at times the greatest enemy of stylized generalization; and this at every stage of his career, in Italy as in England. In detail, his documentation contains nothing merely approximative, nor any prettification by abstraction.

This is true not only of design and composition but also of color. As the *Raft of the Medusa* begins to take form, with the choice among various scenes or episodes still unresolved, one requirement stands firm: the borderline between life and death must be part and parcel of a picture full of physically and spiritually exhausted people, of the dying and the dead. So there come into being those studies painted in the colors of putrefaction, about which Clément said: "He followed with burning curiosity all the stages of suffering, from the first symptoms to the death-agony, and all the marks that suffering stamps on the human body" (p. 130). Such are the *Head of a Corpse* (pl. 51), the heads

cut off by the executioner (pl. 52, color pl. III), and various still-lifes of arms and feet (pl. 53). None of these found final place in the big canvas: what mattered to a man like Géricault was, first, to test his immediate visual experiences; then the rounding-out of a composition lies on a different level. Even here, however, he was led by the documentary principle of rejection of the factitious. He studied and paraphrased the construction of other pictures of all schools, his motive being to forward art by the renewal of tradition. A new integration of the elements once for all delivered to him, not rupture or pulling-down or creation out of whole cloth, is the characteristic originality of Géricault.

The labor over multi-figured compositions of his own begins in the Roman period. The few exceptions from earlier years—the *Bayonet Fight* (pl. 4), the *Artillery Attack* (pls. 10, 11), or the *Death of Hippolytus* (pls. 17, 18)—doubtless depend upon prototypes which we have not yet identified. The first major work, the *Chasseur Officer on Horseback* (pls. 1-3), is essentially a single-figure composition and, stylistically, is an assembly of various components which have been discussed above. Yet it is observed with unprecedented freshness of vision, as in the portrait study (pl. 1); for 1812 it is surprising, and makes us think of tendencies which would be current half a century later; we even think of Goya, though at this date any contact must have been impossible. Here, too, is a borrowing of motives from a sarcophagus and from the *Battle of Constantine* (school of Raphael). Clément reports that studies changed the scheme twenty times; if any other artist had done this, the artistic vitality of the picture would have been worn away, but with Géricault every variant was a spur to integration and intensification. The small oil sketch (pl. 3) is full of a grand dynamism, and is superior to the executed picture in such things as the modeling of the masses, the luscious brush-stroke, and the illuminating power of the colors; it compares well with its prototype, an equestrian piece by Gros. Though contemporary critics sniped at some bad drawing in the neck and legs of the horse, the verve of the color drew great applause. In this first appearance the "young man from Rubens' kitchen," as a studio companion called him, showed ability, power, and impetuosity.

The other works which soon followed, military subjects without exception, included only one of large format, but as solutions to artistic problems they were finer and more mature. In the *Carabinier* (pl. 12) and the *Trumpeter on Horseback* (pl. 9), the link to Gros is broken. The vivacity of the brush-stroke is given up in favor of a rounded modeling of forms; organization of the whole in planes brings drawing and color into complete harmony. Géricault's painting now seems more considered and sedate; it no longer recalls any other

artist's style. The expression of concentrated or husbanded strength given by the model is the most marked characteristic of this time and style; and certainly these pictures have that distinction which the world calls *style* and the vernacular calls *class*. If such paintings had been shown at the time instead of the *Chasseur Officer* (pl. 2), the misconception of Géricault as a Romantic might have been avoided. For in these pictures we see something which was to develop further, on into the English period. The placement of the figure within the boundaries of the canvas, the relation of planes between the subject and the background, the salience of the paler tones and the illuminated parts against darker but still colored areas, all this lies on the main line from David and Prud'hon to Degas and even Manet, but it does not lead by any means to Delacroix. The *Horse Frightened by Lightning* (pl. 7), with its clear profile, is another example; the well-known picture of the same subject by Delacroix in Budapest, when compared to this, shows how wide a difference lies between.

But it would be misleading to try to sew up Géricault's unique effect in a neat formula. It is true that his lot was to follow the classic, but we must understand *classic* and *classicism* here in the widest possible sense, far wider than current usage understands for the visual arts and nearer to the sense of those words in literary or even musical criticism. Historically, Géricault's effect follows the Classicism of 1800, from which he draws some essential traits of his style. Like Ingres, he represents a derivation from an already derivative style; the difference is that Ingres achieved great purity by a sort of narrowing, while Géricault, who was all for broadening, openness, and abundance, had to take a good many corollary impurities in his stride. Basically he had, however, a strict feeling for style in the "smart" sense; and also in the classical sense he *had* style, but not what Wölfflin meant by style when he was speaking of antiquity or the Renaissance. With Géricault style is not a grammatical and prescribed way of procedure, but much more an integration of varied elements into the work, a synthesis which begins with him and, constantly receiving and mixing in new ingredients, continues into our time. Thus, stylistically, we could call modern art a synthesis of various surviving elements of older art; and only if the amalgam or synthesis is made without character does it bear the bad label of decadence and eclecticism.

To return to the paintings: about the same time as the *Horse Frightened by Lightning,* it is no surprise to find the oil study of *Horse Rumps* (pl. 6). Here (despite high "style" in the modish sense) there is no question of form or style, but simply a visual question-and-answer on another level: what is the texture of different colors of horsehide and horsehair? how does a horse's

tail grow? As there are twenty-four or twenty-five cases, there are just that many answers. An empiricist is at work here, a forerunner of Naturalism, and long before his English period. The drawing of a *Horse and Frightened Officers* (pl. 5) shows the same startling immediacy even if the motif seems to have been borrowed from Gros.

Such scenes as the *Retreat from Russia* (pl. 15), the *Wagonload of Wounded* (pl. 14), and possibly a study for the *Wounded Cuirassier* (pl. 8) must be understood as exploratory sketches or group-studies for an intended vast canvas of the *Downfall of Napoleon*. This is admittedly a guess, for the authoritative Clément says nothing about it. Our hypothesis rests on: 1) a study (pl. 16) which sets up roughly but confidently a theme with dozens of groups and hundreds of soldiers; 2) the conviction that the later episodic projects for heroic paintings on contemporary subjects (the slave trade, the Greek war of independence, the liberation from the Inquisition, and even the Fualdès scandal and the *Medusa*) must have risen in incomplete form from the artist's subconscious long before they were actually cultivated (Gros and Girodet's great battle panoramas and David's *Coronation of Napoleon* impressed everyone, and challenged young artists to seek fame); 3) the fact that this was a period of great popular panoramas, and that Géricault thought well of them, as he showed later by repeated visits in London to the *Battle of Waterloo,* some of whose groups he copied into a sketchbook.

It is a reasonable conjecture that the Napoleonic drama, which was a universal intoxicant, hovered in his mind as the object of comprehensive pictorial treatment.

The great variety of these latter works does not gainsay our hypothesis, for the two large paintings which Géricault had shown in the Salon brought him to a sort of stylistic crisis. The *Chasseur Officer* (pl. 2) shows him at his closest approach to Gros's "poetry of details," from which his wish for relief-like plasticity and fondness for outlines "as strong as wire" soon carried him away. The *Wounded Cuirassier* (pl. 8) of 1814 leads in another direction: Régamey (p. 19) calls it "more personal and less happy, painted powerfully with tight contours, without any notion of rhythmic unity. One senses that a wilful pursuit of modeling for its own sake has been pushed so far that the general effect suffers." Contemporary criticism was no more severe with the painting than the artist himself, as we have mentioned elsewhere.

The outcome was a new attack, a search for grand form by another approach. Géricault now drew towards Girodet-Trioson, contemporary and stu-

dio trainee of David, who in his smaller pictures came to grips with a younger generation's need for fuller impasto and a generally richer sort of painting. Champion and Pagnest worked this vein, but Pagnest's teacher Girodet was more effective. His work and influence have not been thoroughly studied, and are doubtless underestimated. If, for instance, we compare his study, the *Oath of the Seven before Thebes* (fig. 8), with such of Géricault's as the *Death of Hippolytus* (pls. 17, 18) or the *Lovers* (pl. 19), the turn toward Girodet is evident. Géricault's escape from the undisciplined drawing of Gros took place, we believe, under the star of Girodet, whose example opened to the younger artist a similar freedom, but one that involved no loss of rhythmic unity. Géricault nevertheless was seeking solutions at the same time by yet other paths. The *Wagonload of Wounded* (pl. 14) hints, in its powerful handling, at influence from the circle of Caravaggio, while the water-color scene from the *Retreat from Russia* (pl. 15) reminds one in its open, loosely manipulated washes, of drawings by late Venetians, such as Domenico Tiepolo.

By all these routes, taken together, his work could have arrived at the putative great picture of Napoleon's downfall. We do not know why the attempt was abandoned: were there only external reasons such as his love affair and the Italian journey which broke it off? or did he conclude that the various beginnings and trials were not substantial enough to make the big composition viable?

In any case, his work takes on quite a new tone in Italy. The antique on its own ground, the monuments of Raphael and Michelangelo, were new experiences, which he transmuted into a rather dense web of single-figure or group motifs from classic sculpture, woven with compositions of Renaissance ancestry, all seen with a naturalistic eye. The *Prayer to the Madonna* (pl. 21) is a good example. Previously he had worked out his material on three levels (nature study, antique study, synthesis) and assembled his studies and sketches side by side or behind one another; now, in his new way of seeing and expressing, these achieved real unity at once. In this particular drawing, which really cannot be very far from the earliest stage of sketching, the relationships of part to part and to the whole are not only convincing and "natural," but also enlivened by a harmonious equilibrium. Never before had the artist so readily and elegantly solved a problem in dozens of figures; the price he paid for his ease was the renunciation of color. That this limitation was purposeful is shown by the fact that in this Roman period the drawings (and within them the emphasis on line) are dominant (pls. 20, 21, 24, 31); even when black ink and

opaque white are used (pls. 22, 23, 25, 30) their solid tones are not for coloristic effect but to weight the modeling in light and shade.

Gericault weaned himself quickly from the loaded brush-stroke, and let himself be stimulated anew by the sarcophagi to the composition of large groups (no longer single figures) into pictorial wholes (pl. 20). When we consider the source in classical sculpture we can accept the "wrong" drawing of over-broad shoulders and too-massive jaws in the athletic nudes; his trick of doubling some of his outlines seems to date from this period, too. As the baroque late-classic of the sarcophagi took possession of his spirit and temper, the artist reached closer to the style of Poussin. The *Procession of Silenus* (pl. 22) and the *Italian Landscape* (pl. 30) have little detailed correspondence with Poussin, but the entire compositions are full of his feeling. The great 17th-century master had also filled sketchbooks with free copies of antique sculpture, and drawn landscapes in the Roman countryside, under an analogous constellation—namely, when a romantic-baroque storm was about to break.

No one could deny that Géricault must have seen and recorded with great interest many other things besides: his drawings after figures from Michelangelo's *Last Judgment,* oil studies from Raphael's *Pietà,* and a female figure from the *Fire in the Borgo* are witnesses. But even Oprescu, who would have it that Géricault was permeated by Michelangelo, said: "Because of unusual conditions, the memory of the great Italians did not tyrannize over him during the Roman visit, but came to do so much later" (p. 56). It is understandable in the nature of our artist that the important change in his method of presentation—from "the poetry of details" in large format to monumental scale in small dimensions—should be derived from new outside influences; but how Régamey in this connection could talk of Bernini's sculpture, or Oprescu or Fragonard, is puzzling.

Whoever looks over the series of works created in Rome will recognize that the artist's deep feeling for the life of his own time was not overpowered by the presence of classic forms, but refined by them. In the *Prayer to the Madonna* (pl. 21), in the marginal sketches to *Taming a Bull* (pl. 31), and in the *Mounted Herdsmen in the Campagna* (pl. 25), we find only scenes that he himself experienced, not borrowings from other works of art. His true artistic insight lies in this: observed fact and considered form appear in him not as opposites and incompatible, but as complementaries and mutual. The aesthetic error in the formless Naturalism of a later epoch is here forestalled.

Nowhere is this clearer than in the series of studies and projects associated with the *Race of Riderless Horses.* It was the only large picture planned at the

end of the Roman period. Though it was never brought to completion, the fragments and by-products are enough to make it clear that this would have been one of the great trail-breaking pictures of the 19th century. It is possible to gain an idea from various preserved evidences (pls. 26-29) of the regular forming and re-forming that went on in Géricault's complex process of creation. We might well call it a crystallization, on the analogy of Stendhal's famous analysis of the process of falling in love (*De l'Amour,* chapters 2-6). Stendhal describes seven steps: 1) wonder; 2) the visualization of details; 3) the creation of hope; 4) the birth of love; 5) first crystallization; 6) doubt; 7) second crystallization; "a year may pass between the first and second, the twinkling of an eye between the third and fourth." In another place he says: "A crystallization is what I call that inclination or motion of the soul which discovers in every new phenomenon a new perfection of the beloved." We leave it to some critic, qualified to delve into the artistic psyche, to decide how many stages there are in Géricault's crystallizations. When once the whole material can be brought together, drawings and oil sketches alike, this will be worth finding out.

Clément in his day was already impressed by Géricault's curious methods, and wrote (pp. 102 ff.): "When he was drawing a composition, and had loaded it with so many corrections that finally it became illegible, he laid a translucent paper over it and carefully salvaged the definitive lines. On this sheet he continued to draw, correcting and making a second tracing, and so on, until he was almost satisfied. This is why we have a considerable number of variant drawings which differ in only a few particulars. By this method he could give to his designs such sureness of proportion and firmness of contour that even a more elaborate execution could have added no greater perfection; and yet these drawings give no more than the outlines and a couple of details, so that the laity take them for no more than sketches. But of course no one should be deceived into thinking that even those beautiful works are anything but an embryo for the greater one that the strong hand of Géricault could have made. We know from the *Medusa* what breadth, unity, and beauty he could give to a composition if he carried it to completion; so we can imagine how splendid the *Race of Riderless Horses* would have looked on a canvas ten meters long."

The *Horse Race* in Baltimore is boldly struck off. Though it remains close to the scene observed on the Corso and seems not to have passed through many stages of the crystallizing process, it lacks the groping character of a study: it is something complete. In the severe simplifications and confident

grasp of the motifs, in the bold drawing of horse-tamers and tossing manes, in the rounded forms of the foreground and the transition to the flatter background, there is a sort of recapitulation of the studies from sarcophagi and of the qualities acquired during the Roman experience. Of all the paintings of Géricault it is probably the one most packed with motifs and personages; it is full of liveliness and spontaneity, rich in episode. The great rhythmic strength which we notice especially in the pattern of legs in the foreground is not unusual in our artist; but there are also great beauties and remarkable freedom in the handling of the paint itself (pl. 26); this brushwork is reminiscent of Goya, and it opens stylistic vistas towards Daumier and the later 19th century.

A painter of twenty-six, almost in the middle of his short career, here reaches his first really high point. All the essential elements are present: reality of experience, tension, rhythmic motion, relief-like plastic clarity, and a developing color sense. He would only have to loaf along down this well-blazed trail if he were really just the Romantic neo-Baroque artist, the forerunner of Delacroix, that countless critics make him. Géricault himself sees the matter differently. He criticizes the picture because the diagonal arrangement along the rope barrier is too reminiscent of Baroque principles; and so he begins to "crystallize" (pl. 28). He gives up the stirring outlines of modern costume, he gives up the extensive painter-like playfulness in the grandstand, the charming shimmer of the salmon-colored draperies, and even the interesting diagonal of the barrier. The scene is reversed, most of the figures are banished, and out of the simplification of the original friezelike construction grows a simple massive grandeur which leaves classicistic standards behind, but which can be called "classic" in a timeless or transcendent sense.

While the *Start of the Race* may still betray some of the great strain of abridging the forms, the final crystallization, *Capture of a Wild Horse* (pl. 29), is unforced, serene, and clear. Once again people, animals, and buildings have been pruned, and the spiritual dimension is correspondingly enlarged. The cheerful green-and-blue of land and sky predominates, wiping away the deep shadows of the previous "state" of the composition, and giving the whole a sort of blessing of breadth and openness. This, with the precision of rounded modeling and the overlapping arrangement of figures and horses, creates a monumentality that approaches Poussin's in spirit without being solemn. It is another of Géricault's high points.

The breath of fresh air taken in the Roman experience is still evident in two works created just after the return to Paris, the *Horse Market* (color pl. II) and the handsome *Subduing the Beeves* (pl. 32). In neither is the crystal-

lizing process so far extended as in the *Riderless Horses* series, but this does not affect their value. The grand scale that comes of simplification even appears in portraits: one need only compare the *Head of a Soldier* (pl. 35) with the portrait-study for the *Chasseur Officer* (pl. 1) in order to gauge the transformation in style brought about in five years.

The autumn and winter of 1817 were devoted entirely to experiment with new classes of subjects, especially the animal world, and with the technique of lithography. Géricault's attention turned from major structures and their laws to the small, the special; "he steals in," to quote Roger Fry, "with his detective gaze and . . . prodigious visual memory." In the artist's production, there follows a new mode of vision which, besides the usual seeking for plastic form, reaches out for close-up views; it concerns itself with works of small format, and comes to highest expression in his English period. This "little style"—the adjective is not unfriendly—is worked out first in drawings, and turns naturally toward water color, accenting more and more the skin, the texture of its subjects, their polish, their shifting surface. In the field of graphic art this style unfolds step by step in the subtle pictorial values of lithography.

The surviving material and the evidently rapid development—by leaps and bounds—allow us only glimpses here and there into a new dimension of the artist's conceptual world. They are surprising glimpses. The drawing of *Cats* (pl. 36), the *Sprawling Cat* (pl. 37), the *Couple of Lions* (pl. 38) are all early crystallizations from various technical viewpoints (sketch, oil study, technical exercise in rendering). The *Bulldog* (pl. 34), astonishing for this period and possibly therefore somewhat later, is strong as a late Rembrandt and modeled like an early Cézanne. This and the *Bed in a Stable* (pl. 39) are advanced stages in the "crystallized" condensation of the "little style." What a difference there is in the impasto of these juicy paintings and the brushier *Death of Hippolytus* (pls. 17, 18), which is perhaps only two years earlier!

His sculpture should be investigated most thoroughly, if it is right to look at Géricault as a frustrated sculptor, which he is in Régamey's judgment (p. 55): "Modeling with his paint, often giving his brush-stroke the character of sculptor's drawing, he was driven to hew stone. . . . If it is permissible to follow a fairly clear indication a long way into the unknown, we may think of the mature Géricault as a sculptor who is also a painter and who is probably active in large-scale decorative fresco painting."

Régamey probably goes too far. Many other 19th-century painters, with considerably less inclination for sculptural form, occasionally worked in three dimensions: Daumier, Courbet, Degas, Renoir, Gauguin (though never Cé-

zanne). The bronze cast which we illustrate (pl. 95) shows, however, one thing very plainly: that the "grand style" runs alongside the "little style" and consistently permeates even an unfamiliar technique. It shows the artist's ability to express himself in the medium, and it towers over the product of professional sculptors of its decade. But of actual influence there can have been very little, else Géricault's output of six completed sculptures would not have been reduced by five between Clément's note of 1867 and the centenary exhibition of 1924. The missing pieces have almost certainly been destroyed, for (according to M. Luc-Benoit, writer of a study of Romantic sculpture and former curator at the Louvre) not a single other plastic work of Géricault's was known in 1950. The recent rediscovery of another sculpture (see note to plate 95) therefore came as a real surprise.

The coexistence of the "grand" and the "little" styles—this phrase could serve as title to the almost inconceivable number of pictures, variants, studies, sketches in oil, water colors, and drawings, which cluster around the theme of the *Raft of the Medusa* (pls. 41-53). Many of the preliminary studies (pls. 42, 43) are better and more unified compositions than the finished painting. We know that the artist undertook a definitive change at the eleventh hour: the insertion of the corpse trailing in the water in the right foreground. It is a question whether he improved the composition or merely complicated it. What is certain is that in marshaling the figures and groups he fell far behind his performance in the *Riderless Horses* series. The painting is not far enough crystallized; or, to be precise, it has stuck between two stages of crystallization. As it stands, it is too much and yet not enough. It has wonderfully thrilling passages, islands of the "little style" which, when isolated, seem poorly incorporated into the great mass. Astonishing as it may sound, this huge canvas, the largest Géricault ever executed, could hardly have been undertaken at a less suitable time. If it had been created at the end of the Italian period or shortly after, it might have partaken somewhat of the cachet of *Subduing the Beeves* (pl. 32), and of the "grand style," even in a modern subject without colorful accessories. And if it had been done soon after the stay in England, then doubtless the interpenetration of the "grand" and the "little," rather than their coexistence, would have become its chief concern. In the situation of 1818, however, the two styles fall apart. There are studies, such as the *Heads of Guillotined Men* (color pl. III), which go the limit in a given direction, and which belong among the most personal work of their author; but they do not conform to the idea of the great picture, and they were not used. The same is

true of the *Still-Life with Arms and Feet* (pl. 53), the *Head of a Corpse* (pl. 51), and the single *Head of a Guillotined Man* (pl. 52).

The *Mutiny* scene (pl. 46 and especially pl. 47), which was soon eliminated, shows a happier hand in the many rich and painter-like documents of realistic observation. There is nothing wooden or pedantic or oversubtle in the whole thing. If we may use such an expression in regard to this wild story, we can say that here order and freedom are marvelously companionable. In no other picture did Géricault contribute so important and original an essay in realism to the solution of the problem of form. How well the sheet of paper would stand enlargement to a canvas twenty times the area is another question, which it would be idle to argue.

After these remarks on some questions of style which the *Medusa* complex raises, it may not be uninteresting to pursue the sources from which, according to his method, the painter of this giant canvas drew his inspiration. I have already mentioned certain sarcophagi and Michelangelo. Then a little-known 18th-century painter, Doyen, can be identified as the source of one head-study (pl. 49). Fortunately, many of the biographers not only recount all the anecdotes that have more or less connection with the picture, but also name the prototypes of pictorial motifs and so inform us of the truly universal capacity of the artist for absorbing influences—a fact which in no way diminishes his originality. These identifications often refer only to a single figure or to a general impression. Clément sees "quite superficial influences" from Caravaggio, the Bolognese, and even Jean Jouvenet; the young man in the center, who tries to lift himself by the arm and shoulder of his neighbor (pl. 44, lower left), reminds him of Michelangelo. Rosenthal (p. 90) judges somewhat more severely: "Here one is aware of the hours he spent in the Sistine Chapel. The remembrances of Michelangelo, conscious or confused echoes of the *Last Judgment,* keep the fever burning; these heroic naked figures, who fall headlong into the water, are inspired by the Damned. For a moment Géricault was seduced by the folly of [exaggerated] musculature." Régamey is sure that in the first sketches "he is evidently led astray by Michelangelo; later he abandons Michelangelo's poses because of their obtrusiveness; he includes the figures in a general motion which rises to the wildly flapping bits of clothing" (p. 30). Oprescu further finds (pp. 108 ff.) in the double-diagonal construction and the light effects with strongly contrasting shadows an influence of Caravaggio, probably coming through Girodet; while in details he sees the hand of Michelangelo, transmitted through memories of Gros's *Battle of Eylau* and *Napoleon Visiting the Pesthouse at Jaffa*—all this, however, clouded over by

the example of his now forgotten contemporary Jean-Victor Schnetz, a pupil of David.

These observations are of the highest interest. They show that so "late" a painter as Géricault—and by implication his whole century—had before his eyes the whole treasury of Western art-forms, and by no means trespassed if he used these values as means to new ends. Only if the artist uses them as ends in themselves, making nothing beyond them, is there wrong done. Oprescu rightly says: "It is Géricault's merit, and his good fortune too, that he understood how to harmonize the images of what he most deeply admired with his artistic aims and the lucid quality of his work" (p. 118).

It may be doubted whether the *Medusa* is among his best performances. Despite great beauty in details, it does not give either the clearest or the strongest presentation of what the artist sought. It lays itself open to criticism at too many points, and although it is the only subject-picture that reached completion, it is in a profound sense more of a fragment than many of the studies and smaller paintings. The fact that it was for a century almost the unique vehicle of the artist's fame, is one of the chief causes of the misunderstandings which have clustered about Géricault's art.

The break between the *Medusa* period and the subsequent stay in England is more marked than any other, and yet what was now to come had been announced in earlier works. The painter could not have profited so much from English stimuli at any other moment in his career. The *Prize Fight* print dated 1818 is so "English" in motif and form that it has appeared in more than one exhibition among works dating after 1820. The contact with graphic art, with small format, and with the idea of serial representation had already been established in the Fualdès cycle (pls. 54-59), made in the period of the *Medusa*. Thus the artist has become receptive to sporting prints, a source of inspiration that displaces for the first time the memory of antique sarcophagi. Even now, nevertheless, the forms still lie in almost parallel layers.

His interest is shifting more and more to realistic scenes from daily life, sometimes rather banal in content. The elaborate details may be connected with the preceding "little style." The picturesque aspects of the scene evoke, even in the black-and-white technique, a painter-like vision of tonal transitions and contrasts. In the most rapid of sketches, the sharply outlined shapes are displaced, softened, or eaten up, little by little, in the interplay of light and shade running all over the surface (pl. 64). The "snapshot" character, the spontaneity in such scribbled drawings, is a new direction in Géricault's art.

A further element with which the English visit enriched his style is a new

sense for color or, more precisely, the conquest of the water-color technique which was just reaching its high point in England with Thomas Girtin, John Sell Cotman, Bonington, Constable. No longer was Géricault's color the last-minute decoration added to complete the drawn form of the early military figures. It was now a constructive validation of color. To quote Oprescu (pp. 150 ff.): "Every tone has its claim to existence and takes its part in the total effect. Its density is directly related to the scale of the picture. The brush stroke goes in a certain direction and no other; its radius may not be lengthened, nor the thickness of the paint-film reduced or increased. . . . The way in which the tone is placed is as important as the tone itself." Here was an attack on the problem of tectonic analysis of color—analysis which would be carried to its extreme at the end of the century with Seurat, and which then would be credited to Delacroix (Paul Signac, *D'Eugène Delacroix au Néo-Impressionisme,* Paris, 1899). If one person must be singled out and given credit for having initiated this new trend, it is Constable, whose fame Géricault spread on his return to the Continent, and whose influence in large measure began with his exhibiting in the Salon of 1824.

Once more it was Géricault's trail-blazing function to synthesize two tendencies, the special form (adapted to water color) of the English landscapists, and the realism of sporting prints, and then to make something new of them. In such drawings as the *Hanging* (pl. 68) or the *Coal Wagon with Five Horses* (pl. 75), the breadth of the newly won territory is readily seen. What the artist lost in classic grandeur (cf. the *Riderless Horses*) or in baroque pathos (cf. the *Medusa*), he made up by stretching forward to an open modern formulation. There are some fine direct hits and, with them, some hesitant and all-too-provisional scribbles. The *Fishmonger* (pl. 65) is interesting, but in many respects *too* interesting, too full of illustrative meaning. The "little style" can stand less of this than the "grand" one. The large lithograph, *Pity the Sorrows of a Poor Old Man!* is on the whole too sentimental: just a small detail (pl. 67) is enough (though it almost suppresses the moral flavor) to validate the richness and the velvety saturation of tone, to emphasize agreeably the tectonic elements in the construction. The same criticism is brought forth by the print of the *Paralytic Woman* (pl. 70). Then there are other sheets with less ambitious "social significance" which are unified, concentrated, round, and full, such as the *Flemish Farrier* (pl. 69) with the solid form of the horse in the middle and the painter-like illumination, or the *Entrance to the Adelphi Wharf* (pl. 72) with its balanced rightness in form,

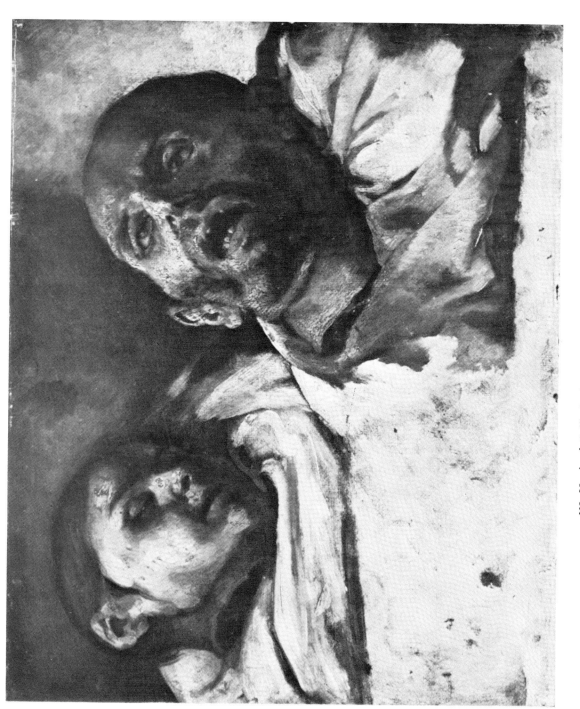

III. Heads of Guillotined Men. Stockholm, Nationalmuseum

space, and values. Each of these three works would have aroused the wonder of the moderns half a century later.

The great work of the English period, the only painting larger than sketch format, is the *Epsom Derby* (pl. 74). It is hard to say enough about this remarkable picture. When it appeared at the Louvre in 1866, it came at just the right time for an astonished reception by the rising artistic generation, who took it almost as a revelation. How much of Manet, Degas, Seurat, Lautrec is prepared here, and by no means only in the choice of subject! Friedrich Antal, who delved deep into the problems of Classicism and Romanticism, says in one of his articles: "[Géricault's late work] gives an early foretaste of a phenomenon often met in French figure compositions of the second half of the 19th century, of the thin borderline between Classicism on the one hand and the different shades of Impressionism on the other" (*Burlington Magazine,* vol. 78, No. 454, p. 19). Instantaneous appearance has received its own pictorial form here for the first time; there is no more reminder of the "historical" composition or of any style out of the past. On this account, it is important to make it clear that we are dealing with a mixture of the most varied historical elements (Classicism, water-color technique, the popular art of broadsides and sporting prints, etc.) in a close integration.

Ever since photography became capable of freezing a moment of the wildest gallop, it has been understood that no running horse has all four feet off the ground for a fraction of a second. So, in our scientific idolatry, we may state that Géricault's concept of the instantaneous is based in error. But, let him be ever so wrong "scientifically," the higher artistic truth, which depends on convincing appearance rather than on a camera's outwitting reality, could not be more strikingly proved. In the famous jumping horse in the *Battle of San Romano,* Uccello had long since improved on nature by his intuitive power to convince.

A variant of the *Derby* is shown in the *Jockeys at the Gallop* (pl. 73), an unfinished study which is almost more surprising. The distance from beholder to picture plane has been abridged until the action is almost under one's nose. The picture is hardly one of moving horses and riders, but of motion itself, which seems to permeate the subject. An almost stenographic abbreviation of form in the horses' necks anachronistically suggests streamlining. Such a welding-together of parts into a flying or floating unity has not been seen before. The head of the third and the rump of the fourth horse disappear in the galloping mass, and are not missed for a moment. If we look back from here to the sculptural poise of the *Capture of a Wild Horse* (pl. 29), only four years

earlier, we can gauge the distance between these antipodal possibilities, and from it the stature of Géricault's art.

Just as he had done before, he would have striven to synthesize these polarities on a new level. After the return from England in 1822 this Cézannesque achievement would have been a great task for him; all the necessary conditions were present. The "grand" and the "little" styles had grown each to the highest crystallization, and a new unification was due. Rosenthal soberly declares that the *Epsom Derby* contradicts the *Raft of the Medusa* and revokes the *Riderless Horses*.

Only a few starts were made, but in them a new phase of style is at least suggested. The ten months remaining before Géricault took to his bed were so filled with extraneous troubles—riding accidents, speculation, imprudence—that artistically the period seems relatively rich and fruitful. Although Clément treats the work of those months as a sort of appendix to the English period, and thereby disavows any essentially new direction, it is useful to look at the question more closely. The late pictures (pls. 76-94) exhibit various stylistic elements. One can set up three groups which often overlap but which have real differences. First come such projects as continue earlier tendencies: the sketches for the intended gigantic canvases of the *Slave Trade* and the *Liberation of Victims of the Inquisition* (pls. 85-87) are of the first importance for insight into the artist's ideas, but at this stage of the conception they do not go beyond anything that has already come to light in the earlier drawings for the *Medusa* and the *Fualdès Story*: development from a classical composition. Even the *Coal Wagon with Seven Horses* (pl. 76) is only a rehandling of English materials; the composition is more close-knit than that of the *Coal Wagon with Five Horses* (pl. 75), but this is readily explained by the differing artistic climate of the Continent, where a stronger Classicism was in the air. I count the admirable *Wine-Barrel Cart* (pl. 77) among this group: from its theme, it must be of French origin, while its rich tonality and the unclassic physique of the horses date it after the English visit instead of before (as Clément would have it).

The great artistic event after Géricault's return was the Salon of 1822. It included nothing of his, but it did show Delacroix's *Bark of Dante,* the first invasion of Romantic painting. This work was much discussed in artists' groups, and we hear from a good source (Henry Lachèvre: *Détails intimes sur Géricault,* Rouen, 1870) that Géricault let himself be led to the new wonder, looked hard at it, and expressed himself favorably. His companion was of the opinion that Delacroix would not have been so daring without the Medusa for

precedent. "That is quite possible," said Géricault, "but this is a picture I should be willing to sign." Does not this show that the artist, at his own cross-roads, kept well in mind the demand for color that had been going up ever since Gros, even though he himself never swallowed the Romantic program? The emergence of a rather Oriental variation in a few sheets of studies and the interest taken in Persian miniatures (fig. 6), remind us that color dawned on him in a new symphonic sense as something that could be integrated and, so to speak, orchestrated into earlier elements. It is not the superimposed local color of the early military pictures or the structural sort from water color. Rubens seems to have given him the cue for the *Lion Hunt* (pl. 84), which looks like an anticipation of Delacroix's work of the late 'fifties. The *Negro on Horseback* (pl. 83) unites the antique rider-motif with modeling in color and the style of the Oriental miniatures—a broad grasp, this—and the *Negro Soldier with Lance* (pl. 82) allows an association of the erstwhile tight "wire-bound" outline drawings with thorough tonal modeling of the surfaces. All this means a coming to terms with the painter-like tendencies of rising Romanticism, but it does not mean going over into the other camp. A few drawings and the fine portrait-study of *Madame Bro* (pl. 80) are traces of another budding, but nothing can be said about what might have come of it in larger projects, or whether a new style would have developed. Untimely death put a full stop to it.

The last group of works from this period takes quite a different direction, contradicting in many ways both the post-English and the proto-Romantic tendencies. According to Régamey, the newness lay in a successful search for color gradation; Oprescu put it this way (p. 160): "One can imagine no other sort of painting which is at once so restrained and so rich, no juster eye, no more knowing hand, no greater economy of means, and no more stirring effect." This group includes the portraits, the *Landscape with a Lime-kiln,* and the scene from the *Greek War of Independence*. It could well be that "these bold but supple brush-strokes, which model and envelop the form, derive from the inheritance of Hoppner" (Oprescu) and the older English portrait school; but in the way they were used something new showed itself, which had been present neither in Géricault's earlier work nor anywhere else. In the Greek scene (pl. 78), one is most easily reminded of Goya, who anticipated so many coming things in the 19th century.

The *Landscape with a Limekiln* (pl. 88) is a great event in a half-century almost without landscape painting, for it represents the widest synthesis of the preceding manners of the artist and points, besides, to a distant future. Neither

Courbet nor Cézanne would have refused to acknowledge this full and luscious painting. No other landscape painter, not even Constable or Corot, achieved with three tones (green, brown, and yellowish grey) such compactness of impression along with balanced construction and spatial clarity. Géricault painted many pictures of greater force and with more astonishing effects, but none to approach this in natural rightness and completeness. All his experiences in four previous stages are so summed up here that in the end the complex pattern has a simple effect, and can be read as a direct realistic statement.

Just so with the eight portraits. The *Louise Vernet as a Child* (pl. 81), with its willful misdrawing and the slightly queer pose, recalls earlier work and the school of David, but the almost abstract solid geometry of the rounded forms, especially the arms and legs and the back of the neck and head, together with the tonal gradations of the blue dress, point to a later time, in fact directly to Courbet. This work must date from about the time of the portrait of a *Negro* (pl. 89), in which the crystallization is admittedly carried to a further stage, where the various stylistic components are completely absorbed in the new unity. Is this a formation on classic principles, or does the color take the lead, or are the realistic elements the decisive ones? These are idle questions, because the artist has reached an organic fusion and, in doing so, has moved ahead of his time. Here he takes up the same special position as Corot, Manet, and Cézanne after him: not to be caught in the pseudo-political division of the century and have to admit partisanship of either color or line. If it was Géricault's misfortune to be known to several generations through three pictures only, how we must wish that such a work as the *Negro* might have been among them: more than one false step of connoisseurship might have been avoided. In presence of this work, it is understandable that its creator could write at about the same time: "I have long since come into harbor, and will try, without passion or rivalry, to light a sure and true way in" (Clément, p. 238).

At the very end come the five existing portraits of the mentally ill (pls. 91-94), to which the *Man from the Vendée* (pl. 90) is related stylistically if not by subject. Here begins a new and great chapter in the artist's achievement. Even without any previous comparable works, it can still be said that this performance is unthinkable except on the basis of the English experience. One would be tempted to draw a connection with the later Goya, but this influence was not felt in France before 1829; nor is it likely that Géricault had seen Goyas in an English collection.

Possibly the realistic note is the most startling, the receptive temperate

observation, the penetrating recording of facial traits, of the general bearing (a sort of motionless gait), even of the way in which the subjects have put on their headgear—all this without falling into the formlessness of Realism or the fortuitousness of the snapshot. The distinction of the series lies only to a small degree in the character of the models, and much more in the style of the painter. But, in contrast to his Roman practice of transforming or stylizing appearances in order to breathe grandeur into them, he rather gets under their skin, and animates them from within, giving his subjects more suggestive and communicative power than his sitters naturally possessed. Though this no longer has anything to do with Classicism, yet it is an extension of the classical view of a higher (or perhaps deeper) reality—at any rate of a reality which is transposed to a vision.

If one looks back from these pictures of the mentally ill to the beginnings, to the portrait of *Lieutenant Dieudonné* (pl. 1), only ten years older, Géricault's work looks, despite its fragmentariness in many respects, like a gigantic performance. In a time of considerable artistic uncertainty and of much hunger for revaluation, it was a great enterprise to go to the root of the matter and to set up new criteria between old and novel, original and false, order and freedom. As a successor to the neo-classic school of David, Géricault wrestled with problems of style even as he strove for an expression of modernity. In the return to the true classical "antique," he became one of the most important forerunners of the moderns. In the reconciliation of artistic derivations from Italy and England—he was the only artist of his century to have roots in these antipodes—he came to a synthesis of real originality. He reached no fixed point, he proposed no great new program, but he gave an example of a crystallizing process that drew ever nearer to perfection. With it all, he showed an astonishing instinct for foreseeing the future.

Until the late 'seventies of the last century, it looked as if color and everything that went with it pointed to the future, as if the world of line and solid geometrical form were backward-looking, as if Ingres were a reactionary, and his opposite Delacroix the maker of forward strides. We now recognize that these ideas were limited. If we have to choose between Ingres and Delacroix, then we must join Jean Cassou in recognizing the former as artistically the more vital and far-reaching power, with a positive influence even on Cubism. But we shall probably not have to make the choice at all if we realize that the split in the arts as between line and color was historically an inevitable oversimplification of the 19th century. At the end of that century stand Cézanne, Seurat, and Lautrec, a whole generation tagged with the meaningless

name of Post-Impressionism. What unites them all is the fusion of color prin-
ciples with linear and plastic principles of form, different though their in-
dividual expressions were. Looking backwards from them, we see in every
generation of the century an heroic attempt to bridge the "either . . . or" gap
with a "both . . . and" (see the author's book *French Master Drawings of the
19th Century,* New York and London, 1950). Chassériau stands between
Ingres and Delacroix; Manet, Degas, and Renoir try, each in a different way,
to steer between the extremes.

Géricault was the first who marked out a course in this direction. He re-
cognized what was good in the Davidian reform, and spotted its meagerness
at the same time; he let himself be dragged for a while into the colorful al-
lurement of Gros, to develop later a more settled painter-like form of his own.
That was his mission as a pilot for painting in his century. This side of his art
can be explained. The rest, the attracting power of his fragments, which ex-
cite our imagination, the grand forms and the vitality of his pictures, their
convincing order and their electrifying brilliance,—that side of Géricault's art
keeps many impenetrable secrets. It seems that this artist stands closer to our
century than to his own. Now he is better known, more admired, more deeply
loved.

V. Chronology

1791 26 September: born in Rouen as son of the jurist Georges-Nicolas Géricault and Louise-Jeanne-Marie Caruel.

1792 Move to Paris.

1801 Death of his mother.

1806 Education in the Pension Castel, and later at the Collège Louis-le-Grand.

1808 Pupil of Carle Vernet.

1810 Entry into Guérin's studio. Imperial decennial competition. Study from old masters and antique sarcophagi in the Louvre.

1811 Studies of horses, done at Versailles.

1812 *Chasseur Officer on Horseback Charging.*

1813 Move to the studio in the Rue des Martyres. Zubaloff Sketchbook.

1814 With the Royal Musketeers. *Wounded Cuirassier.*

1815 Horace Vernet becomes his neighbor. Acquaintance with Colonel Bro, Béranger, A. -V. Arnault, Eugène Lami, the Duc d'Orléans, *et al.* Studies for the series of pictures on Napoleon's fall; *Retreat from Russia.*

1816 Liaison with a married woman. Trip to Italy. Visit with Ingres. "Classical" drawings; *Race of Riderless Horses.*

1817 Return to France. Acquaintance with Delacroix. *Subduing the Beeves.* Studies of animals, done in the Jardin des Plantes. First lithographs.

1818 Birth of his son. Studies for the *Medusa,* done in the studio near the Hôpital Beaujon.

1819 *Raft of the Medusa;* Fualdès cycle.

1820 Trip to England. Traveling exhibition of the *Medusa.* November: visit to David in Brussels.

1821 Great English series of lithographs; water colors; *Epsom Derby.*

1822	Return to France. Illness. Delacroix's *Bark of Dante* in the Salon.	Portraits of the insane. *Landscape with a Limekiln; Negro.*
1823	Invalidism.	Sketches for the projects *Slave Trade* and *Liberation of Victims of the Inquisition.*
1824	26 January: Death in Paris at age 32. Burial in Père Lachaise.	

VI. Bibliography

The fundamental work is still:

Charles Clément, *Géricault. Étude biographique et critique avec le catalogue raisonné de l'œuvre du maître;* Paris, 1867; later editions 1868 and 1879.

One of its most important sources is:

Louis Batissier, "Géricault," in *Revue du XIXième siècle,* 1824.

The monographs most frequently cited in the text are:

Léon Rosenthal, *Géricault* (in the series, *Les Maîtres de l'Art*), 1905.

Raymond Régamey, *Géricault* (in the series, *Maîtres de l'Art moderne*), 1926.

G. Oprescu, *Géricault* (in the series, *À Travers l'Art français*), 1927.

An especially useful collection of texts and sources is in:

Pierre Courthion, *Géricault* (in the series, *Les Grands Artistes racontés par eux-mêmes et par leurs amis*); Geneva, 1947.

Illustrative material may be seen in:

Maximilian Gauthier, *Géricault* (in the series, *Les Maîtres,* inexpensive), 1935.

Loys Delteil, *Théodore Géricault* (critical catalogue of the graphic work, volume 18 of the series, *Le Peintre-Graveur Illustré*), 1924.

Charles Martine, *Théodore Géricault* (in the series, *Dessins de Maîtres Français*), facsimile publication of 58 drawings from Paris collections, 1928.

Les Dessins de la Collection Léon Bonnat au Musée de Bayonne; 3 volumes, 1924-1926.

For Géricault's artistic importance:

Raymond Régamey, *Hommage à Géricault* (in the series, *Les Cahiers du mois*), 1924.

Stylistic presentation of the drawings:

Klaus Berger, *Géricault. Drawings and Watercolors* (in the series, *Bittner's Art Monographs*), New York, 1946.

Detailed information on Géricault:

Henry Lachèvre, *Détails intimes sur Géricault;* Rouen, Lapierre, 1870.

Antoine Etex, *Les Trois Tombeaux de Géricault,* 1885.

Jean Gigoux, *Causeries sur les artistes de mon temps,* 1885.

Jules Breton, *Nos Peintres du siècle,* 1900.

Géricault and the art of his century:

Gustave Planche, *Portraits d'Artistes,* 1853.

Ernest Chesneau, *Les Chefs d'École,* 1862.

Charles Blanc, *Histoire des Peintres, Ecole Française,* vol. III, 1865 (most undependable).

Louis Dimier, *Histoire de la Peinture française au XIXième Siècle,* 1914.

Henri Focillon, *La Peinture au XIXième Siècle,* 1927.

Louis Réau, *L'Art romantique,* 1930.

Walter Friedländer, *Hauptströmungen der französischen Malerei von David bis Delacroix* (in the series, *Neuphilologische Handbibliothek*), 1930.

Roger Fry, *Characteristics of French Art;* London, 1932.

Maurice-Pierre Boyé, *La Mêlée romantique,* 1946.

Louis Réau, *L'Ère romantique. Les Arts plastiques* (in the series, *Bibliothèque de synthèse historique*), 1949.

Articles and catalogues:

Friedrich Antal, "Géricault. Reflections on Classicism and Romanticism," III, IV, V, in *Burlington Magazine,* 1940/1941.

Germain Bazin, *"La Course des Chevaux libres"* in *L'Amour de l'Art,* 1932.

Klaus Berger, "David and the Development of Géricault's Art" in *Gazette des Beaux-Arts,* 1946.

Klaus Berger, *"Un chef-d'œuvre de Géricault retrouvé,"* in *Bulletin de la Société de l'Histoire de l'Art français.* Année 1952.

Charles Blanc, *"Géricault et Ingres"* in *Gazette des Beaux-Arts,* 1864.

Paul Fechter, "Géricault" in *Kunst und Künstler,* 1913.

Eugène Fromentin, *"Un Programme de Critique"* in *Gazette des Beaux-Arts,* 1880.

Galerie Paul Charpentier, Paris, *Exposition Géricault,* 24 April-16 May 1924 (centenary memorial exhibition), catalogue edited by the Duc de Trévise and Pierre Dubaut.

Maurice Gobin, Paris, *Exposition de Dessins, Aquarelles, et Gouaches par Géricault,* 5-21 December 1935.

Bernheim-Jeune, Paris, *Exposition Géricault Peintre et Dessinateur,* 10-29 May 1937, catalogue edited by the Duc de Trévise and Pierre Dubaut.

Galerie Bignou, Paris, *Exposition Géricault, cet Inconnu. Aquarelles, Gouaches, Dessins,* 19 May-10 June 1950, catalogue edited by Pierre Dubaut.

M. Knoedler & Co., New York, *Gros, Géricault, Delacroix. Loan Exhibition of Paintings and Drawings,* 21 November-10 December 1938, catalogue edited by the Duc de Trévise.

Marlborough Fine Art, London, *Théodore Géricault,* October-November 1952, catalogue edited by Pierre Dubaut.

Kunstmuseum, Winterthur, Switzerland, *Géricault,* August-September 1953.

René Huyghe, *"La Genèse du Cuirassier blessé"* in *L'Amour de l'Art,* 1931.

Margaret Miller, "Géricault's Paintings of the Insane" in *Journal of the Warburg and Courtauld Institutes,* IV, 1940-1941.

Walter Pach, "Géricault in America" in *Gazette des Beaux-Arts,* 1945.

Léon Rosenthal, *"La Place de Géricault dans la Peinture française"* in *Revue de l'Art,* 1924.

Robert de la Sizeranne, *"Géricault et la Découverte du Cheval"* in *Revue des deux mondes,* 1924.

Duc de Trévise, *"Géricault, Peintre des Actualités"* in *Revue de l'Art*, 1924.

Duc de Trévise, "Géricault" in *The Arts*, 1927.

Collection du Duc de Trévise, catalogue of the sale, with foreword by Paul Jamot; Paris, Galerie Jean Charpentier, 19 May 1938.

Hans Vollmer, "Géricault," article in Thieme-Becker's *Allgemeines Lexikon der Bildenden Künstler,* 1920.

Nancy Wynne, "Gericault's Riderless Racers" in *Magazine of Art,* 1938.

VII. Notes on the Illustrations

The comprehensive total of Géricault's work, even today, can be estimated only approximately.

The catalogue of Charles Clément is the indispensable basis, and is highly dependable throughout. Clément drew his information from surviving friends of the painter, and himself saw most of the works. In 1868 he listed 159 paintings, 22 copies from other masters, six sculptures, 180 drawings, and 101 prints. To these he added in footnotes three sketchbooks and a number of variants on some unimportant sketches. Almost all have stood the test of time. Two series of drawings must be disallowed; sixteen sheets of human and eighteen of equine anatomy; and five lithographs. The former can be recognized as copies from contemporary textbooks, and Loys Delteil has rejected the latter on good grounds.

On the other hand, a great quantity of new-found works must be added; they have come to light in various exhibitions, led off by the great Paris show of 1924, which the Duc de Trévise arranged at the Galerie Charpentier for the centenary of the artist's death. Never before or since has such a vast Géricault assemblage been visible under one roof: 300 objects. The Louvre, most of the French provincial museums, and above all Paris private collections made works available; the show really amounted to the discovery of a great and unheard-of artist. Besides many of the works listed by Clément, many more were present that he never knew. Over forty came from the Duc de Trévise's own incomparable collection.

The exhibit had effects of various sorts:

1) An artistic personality previously known only by name, or at best vaguely, was now visibly introduced to a broad public. Comment can be found in almost every contemporary French and foreign art journal.

2) A series of other shows resulted, devoted exclusively to Géricault or to a particular aspect of his work. The most important were the exhibition in his native city of Rouen in the same year, the one of drawings and water colors

at Gobin's in Paris in 1935 (75 pieces), that at Bernheim's, Paris, 1937 (175 pieces), Bignou's, Paris, 1950 (75 pieces under the title *"Géricault, cet Inconnu"*), Marlborough's, London, 1952 (66 pieces), and the Winterthur Museum in Switzerland, 1953 (248 pieces). The catalogues of these assemblies are still indispensable documentary material.

3) The 1924 showing encouraged research: a crowd of articles, dissertations, and monographs, of which Delteil, Régamey, and Oprescu are the most important.

4) Finally, a fantastic increase in interest on the part of collectors, which resulted in the finding of many unknown works. All the important examples in America crossed the Atlantic after 1924. On the other hand, the number of false Géricaults has grown appallingly in the last three decades.

No catalogue of the whole work has been compiled since Clément's of 1867. M. Pierre Dubaut, building on the Duc de Trévise's material, has busied himself for decades with this exacting task; in order to be truly complete, the catalogue must cover thousands of sketches and, including all the variants, several hundred pictures.

In the following list, the measurements are given in centimeters, height preceding breadth. "C." and a number refer to Clément (*Géricault. Étude biographique et critique avec le Catalogue raisonné de l'œuvre du Maître;* 1867). "D." and a number refer to Delteil's critical catalogue of the prints (*Théodore Géricault,* 1924; vol. 18 of the series, *Le Peintre-Graveur Illustré*).

FIGURES IN THE TEXT

1. A King on Horseback (after Van Dyck); between 1810 and 1814.

Canvas, 50.8 x 40.6 cm. Bradford, Pennsylvania, T. Hanley collection; from the Ary Scheffer, Samuel P. Avery, Henry Golden Dearth, and Charles Steward Smith collections.

As in so many other cases, the point of departure is an admired work (here probably the equestrian portrait of the Spanish ambassador De Moucada, Louvre No. 1971), and the result is a picture which carries the handwriting of Géricault in almost every line. A series of free copies after Paolo Veronese, Rembrandt, Weenix, are to be seen in Pierre Dubaut's collection. Cf. the article *"Vente Ary Scheffer en 1859"* in *Gazette des Beaux-Arts,* II, 46.

2. Cavalry Battle (after Giulio Romano); about 1813-1814.

Paper on canvas, 20 x 24 cm. Forest Hills, Long Island, N. Y., collection of Richard

Zinser; from the Coutan-Hauguet, G. Vaudoyer, and R. Goetz collections. Exhibited at Bernheim-Jeune's (No. 21), and there dated before 1812.

Not in Clément; his list of paintings "after the masters" must be enlarged. In 1879 Henry Houssaye spoke in the *Revue des deux mondes* of "more than forty" works "after the most varied schools and in the most contradictory styles," which were all created between 1810 and 1814.

3. Boxer on His Knees; about 1821.

Pencil, 8:3 x 11 cm. Bayonne, Musée Bonnat; from Léon Bonnat's collection.

Only in England, where Géricault freed himself from the visual forms of Baroque motion, could he have achieved this sort of "free" presentation of movement itself—not of an object in motion. The *Epsom Derby* (pl. 74) points, as painting, in a similar direction. Not until fifty years later did Degas's drawings show a comparable openness of form and looseness of stroke.

4, 5. Trapeze Performers; about 1821.

Pen, 13 x 8 cm. and 10.2 x 8.5 cm. respectively. Bayonne, Musée Bonnat.

In the course of discovering that new world which the experience of England opened to him, Géricault must have noted down these motifs at the circus; they waited sixty years for Degas and Toulouse-Lautrec to validate them as material for pictures.

6. Figures from a Persian Miniature; 1823.

Pencil and water color, 13.5 x 18 cm. Paris, private collection; from Eugène Delacroix's collection. Géricault on his sickbed turned to the study of Oriental miniatures; when this example appeared in the posthumous auction of Delacroix, who owned it, the E. D. stamp was applied by mistake.

In comparison to the English period, everything is subtler, in the triple rhythm of men and horses, in the firm, rather dark, color; yet it is still loose and open; a synthesis that will not be visible again until Manet.

7. After James Pollard: Horse Race at Newmarket; aquatint by Rosenberg, 1816.

This sporting print is without doubt the prototype of the *Epsom Derby* (pl. 74). Here is significant proof for the fact that Géricault was never, even in England, a mere shallow naturalist or a photographic recorder of details set before him (if there can be such a thing among artists); and further for the fact that, when he did turn to the "minor" arts, he found new perspectives and new inspiration for full-dress painting—in which respect he is again a forerunner of Courbet. His measure as an artist is never more obvious to the eye than when we compare, as in this case, the point of departure with the result, feature for feature.

8. Girodet-Trioson: The Oath of the Seven before Thebes; painted soon after 1800 as a study for an unexecuted picture.

Canvas, 33 x 42.5 cm. Bayonne, Musée Bonnat.

Régamey was the first and only critic to raise the question of Gros's dominant influence on Géricault, and to remark that "the firm and rich brush-stroke" was, after 1810, not an isolated fact. Besides the unknown early works of Champion and the well-thought-of but spottily-known pictures of Pagnest, we must refer to their teacher Girodet. Géricault's *Death of Hippolytus* (pls. 17, 18) shows clear echoes, in the construction and in the color rhythms, of such a painting as this.

PLATES

I. Trumpeter of the Hussars; 1813.

Canvas, 46 x 38 cm. Vienna, Oesterreichische Galerie; from the Sarlin collection.

The work belongs to a series of studies of soldiers, such as the *Carabinier* in the Louvre (C. 54) or the one in Rouen (pl. 12), which lie between the two exhibited Salon soldiers (pls. 2, 8), and which point, more than the work of any other period, to the influence of Gros.

II. Horse Market (C. 75); 1817.

Water color, 23 x 30 cm. Paris, Louvre; from the Hauguet collection.

Loosely connected with the *Race of Riderless Horses* (pls. 26-29), and at all events dating from after the return from Rome.

III. Heads of Guillotined Men (C. 105); 1818.

Canvas, 50 x 67 cm. Stockholm, National Museum; from the collections of A. Colin and Eugène Giraud.

One of the famous studies connected with the *Raft of the Medusa,* though not used in the picture. A copy in the Rouen Museum was long considered the original; a first-class variant, *Two Heads in the Morgue,* is in the collection of Hugh Squire, London.

IV. Madman with Delusions of Military Grandeur (C. 155); 1822/23.

Canvas, 86 x 65 cm. Winterthur, collection of Dr. Oskar Reinhart; from the collection of Dr. Lachèze. See also pl. 91.

I. Early Years, 1812-1816

1. Lieutenant Dieudonné (C. 47); portrait study for the officer in pl. 2; 1812.

Canvas, 44.5 x 36.5 cm. Bayonne, Musée Bonnat; from the Tripier and Bonnat collections.

An early example of Géricault's method of creation, which developed different styles side by side, one for the large picture, another for the detailed study. The open and painter-like handling of a work like this lies stylistically along the route from Goya to Manet, though there can be no question of any influence.

2. Chasseur Officer on Horseback Charging (C. 40); 1812.

> Canvas, 292 x 194 cm. Paris, Louvre; from King Louis Philippe's collection.

The only picture exhibited more than once during the artist's lifetime, it was the foundation of his fame when it appeared in the Salon of 1812 and was hung by the jury as a pendant to Gros's much-admired equestrian portrait of Murat. Géricault was never closer than here to the proto-Romantic style of Gros; with the *Medusa,* this is probably the only generally known work of the painter that was much reproduced and copied, and therefore it shares the blame for the oversimplified classification of Géricault "between Gros and Delacroix." In reality, the artist at this very time had drawn a rider on a rearing horse—in other words, this same motif—from an antique sarcophagus (Zubaloff Sketchbook, fol. 17; see note to pl. 8). At the Salon of 1814 this painting was hung again, this time as pendant to the *Wounded Cuirassier* (pl. 8). Clément states that some twenty sketches and variants exist (cf. pl. 3).

3. Chasseur Officer on Horseback Charging (C. 42); 1812.

> Canvas, 37 x 28 cm. Providence, Rhode Island, Museum of Art of the Rhode Island School of Design; from the collection of Dr. Schweitzer.

Study for one of several variants, the best, of the theme of pl. 2, known to Clément. In studies of small format such as this, the verve of the early period is more readily seen than in the two great Salon pictures (pls. 2, 8).

4. Bayonet Fight with Mamelukes (C. 38); about 1813.

> Black chalk, with brown ink and white heightening, 20 x 28 cm. Paris, Louvre; from the His de la Salle collection.

The motif was inspired by paintings of patriotic content such as those painted by Gros, Girodet, and others, and especially valued by the imperial government.

5. Horse and Frightened Officers; about 1813.

> Pen and wash, 18 x 25.6 cm. Bayonne, Musée Bonnat; from Léon Bonnat's collection.

This sketch, based on a motif from a battle scene by Gros, is a good introduction to the swinging power of Géricault's graphic handwriting in the early period. It is not related to any of his paintings.

6. Horse Rumps (C. 51); 1813, from the end of the stay in Versailles.

Canvas, 63 x 91 cm. Paris, collection of the Vicomtesse de Noailles; from the Seymour, Couteaux, and Hagens collections.

7. Horse Frightened by Lightning; 1813 (Versailles).

Canvas, 50 x 60 cm. London, National Gallery; from the Martin and Duc de Trévise collections.

Géricault at this time, as again later in England, devoted himself for long periods exclusively to painting horses.

8. Wounded Cuirassier Leaving the Field (C. 52); 1814, shown that year in the Salon.

Canvas, 292 x 227 cm. Paris, Louvre; from King Louis Philippe's collection.

The picture had little success with critics, and eventually gave pain to the artist himself. Clément justly says: "The execution of this work is full of holes and not well-rounded; it will not bear analytical examination. . . . The drawing of the figure is uncertain: it has an empty look, and the yanked-together horse is simply impossible." Nevertheless: "This grand composition is invested with great power and a sense of devotion; in exaltation of thought no work of Géricault surpasses it." The work shows how the artist emancipated himself from Gros's shimmering color and strove for firm and rhythmic drawing. Despite recent cleaning, the picture is today in precarious condition, the bitumen content of some colors having ruined many parts. After its reception in the Louvre in 1851 this work was frequently studied by the pupils of the École des Beaux-Arts. There are copies in much reduced format in the museums of Boston, Brooklyn, and Princeton University. The Louvre also has the so-called Zubaloff Sketchbook which contains a lot of sketches for this painting; they have been published and brilliantly analyzed by René Huyghe (*Amour de l'Art*, 1931, pp. 69 ff.).

9. Trumpeter on Horseback (C. 60); probably 1815-1816.

Canvas, 70 x 57.5 cm. Hollywood, California, Edward G. Robinson collection; from the Binant, Leclanche, and Oscar Schmitz collections.

Painted toward 1812, according to Clément; according to Régamey, in the last period (1823); but most likely at the end of the period of equestrian pictures 1815-1816.

10, 11. Artillery Attack (C. 49); painted between 1814 and 1816.

Canvas, 90 x 144 cm. Munich, Bavarian National Collection; from the Alfred de Dreux, Etienne Arago, Isabey, Comte d'Espagnac, and Jules Lecesne collections.

This unique case of a "military landscape" in the painter's work has been repainted by a strange hand in several places, notably the dark sky

on the right and the top center. There is a copy in the Museum of Le
Havre.

12. Carabinier; 1812-1813.

Canvas, 63 x 53 cm. Rouen, Musée des Beaux-Arts; from A. Vollon's collection.

Régamey says of this picture that it shows a "mastery, strength, and
sureness" which Géricault, "despite enlarged capacities, never surpassed."
A half-length picture of the same model is in the Louvre, a superior study
in the Moussali collection, and a copy in the collection of Hans E. Bühler.
Because of a technical mishap, our plate does not represent the Rouen
painting, but a replica from the Coats collection in Glasgow.

13. Veteran; 1814-1816.

Canvas, 59 x 47 cm. Paris, collection of Aimé Azam.

Exhibited in the Géricault centenary of 1924, No. 244, and in the exhibi-
tion of French Portraits, 1945, No. 51. Probably a portrait of Colonel
Langlois, who, according to Clément, was one of the circle of Horace
Vernet in the Rue des Martyres, always wore a policeman's cap, and later
opened a panorama.

14. Wagonload of Wounded (C. 64); probably soon after 1814.

Canvas, 31 x 29 cm. London, collection of John Hugh Smith; from the Sauvé, Tabou-
rier, de Beurnonville, Thiébault-Sisson, Duc de Trévise, and P. Dubaut collections.

A pen sketch for this picture (Géricault Centenary, No. 44) has on the
verso several studies of the dog which appears in our pl. 60; should the
date on this account be put forward to 1818-1819? Clément remarks a
similar placement of the wagon in the lithograph of 1818, *The Milkmaid
and the Veteran* (D. 7).

15. Scene from the Retreat from Russia; probably about 1814.

Water color, 25 x 21 cm. Rouen, Musée des Beaux-Arts.

The fall of Napoleon and especially the retreat from Russia absorbed
the artist's interest from 1814 through the Italian journey and up to the
time when the *Medusa* took all his attention (1818). The latest evidence
is a lithograph (D. 13). The present water color may be one of the earliest
aquarelles. The intended large picture came no closer to execution than
the sketch (pl. 16). Another episode from the time of Napoleon's fall is
visible in pl. 14.

16. Retreat from Russia; probably about 1815.

Canvas, 84.5 x 152 cm. New York, Germain Seligman collection; from the collections
of Alfred Baudry and the Duc de Trévise.

Thematically this splendid work is attached to the series of pictures hav-

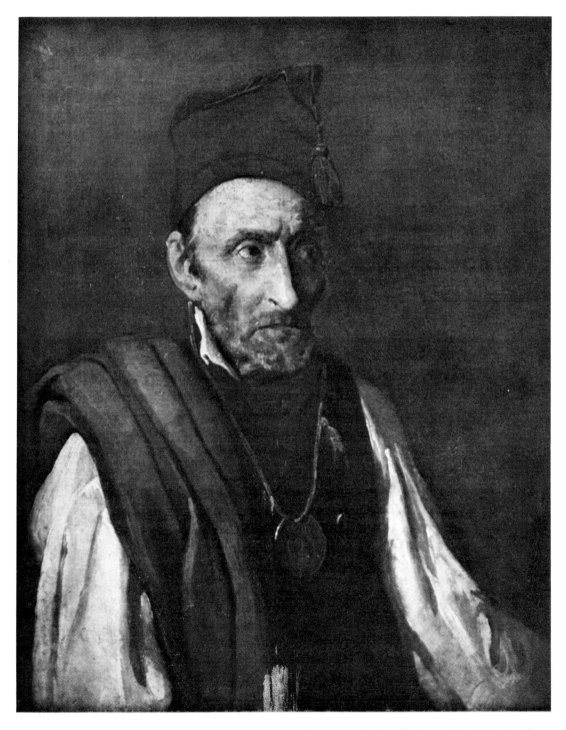

IV. Madman with Delusions of Military Grandeur. Winterthur, Switzerland, collection of Dr. Oskar Reinhart

ing a military character; it is a monumental vision which must have been created under the impress of Napoleon's collapse; in many respects it was prepared by *all* the works that went before it, and it is one of the shrewdest strokes the young Géricault was capable of. The picture is not completed; this may be a blessing, for it is hardly conceivable that the painter would have allowed the outflung mantle of the oversized rider in the left center to remain as it is. Every correction would have meant a devaluation of form and a reduction in expressiveness. That the sky, with its sensitive tones of silver-grey, rose, and blue, its blazing red and smouldering yellow, is not "finished," but keeps the character of water color; that the applied accents in white sparkle all through the composition; that the forms and rhythms of the tumult seem to swallow up the shapes of objects; —all this lifts the work, whose qualities are only hinted at in the photograph, beyond the concepts of 1815, and brings it close to the Expressionists and Post-Expressionists of today. The painting lay unnoticed in a private collection in Géricault's native city, Rouen, until, found by the Duc de Trévise, it was brought safely to America just before World War II, and again made known by its new owner in 1952. See the author's article, *"Un chef-d'œuvre de Géricault retrouvé,"* Bulletin de la Société de l'Histoire de l'Art français Année 1952.

17, 18. Death of Hippolytus; probably about 1815.

Canvas, 26 x 38 cm. Montpellier, Musée Fabre; from the Bruyas collection.

Shows certain relations to the style of Girodet-Trioson (cf. fig. 8), in whom Géricault evidently became interested after he turned from Gros. This assumption would allow a dating soon after the military subjects and, along with the classical theme, point to the approaching turn towards Italy. The rather rare motif of Hippolytus' violent death had not been used since Rubens and Poussin.

19. Lovers (detail); probably about 1815-1816.

Canvas, 24 x 32.5 cm. Geneva, Dr. F. Firmenich collection, from the Cogniat collection.

This hitherto unpublished picture was in 1950 in the Galerie Kagonovitch, Paris, whose director kindly secured permission for reproduction. The photograph shows only the central portion, which is surrounded by broad dark margins on all sides.

II. Rome, 1816-1817.

20. Battle of Cavalry and Infantry; 1816 or 1817.

Pen and ink, 22.2 x 29.6 cm. Bayonne, Musée Bonnat; from Léon Bonnat's collection.

A very similar drawing (C. 28) is assigned by Clément to the early period, and dated about 1812. A comparison with the drawing of a thief brought to execution (Centenary Exhibition, No. 100, reproduced in the catalogue) shows, in the rider and the horse seen from the front, such similarities to the present one that placement in the Roman period is inevitable. It follows that Géricault's study of antique sarcophagi was continued in Italy, for such sculpture is the basis of this relief-like way of seeing. A companion to this drawing is reproduced in Berger, *Géricault: Drawings and Watercolors,* fig. 12.

21. Prayer to the Madonna (C. 76); 1816.

Pen and ink, 26.5 x 40 cm. Paris, École des Beaux-Arts; from the His de la Salle Collection.

The Duc de Trévise considered this one of the artist's happiest compositions (Centenary Exhibition, No. 99). Probably from observation of street scenes which, under the influence of "the masters," were transformed into a firm but rhythmic order. Most of the elements of the Roman repertory are already present: the horseman (see pl. 25), the youths holding horses by the bridle (see pls. 26-29), etc.

22. Procession of Silenus (C. 81); 1816-1817.

Pencil with sepia wash and white heightening, 20.5 x 28 cm. Orléans, Musée des Beaux-Arts; from the collections of Camille Marcille and Lesourd.

The "instinctive effort at stylization" (Régamey) gives full play in this and the following sheets to Géricault's individual note. The same motif is varied in a long series of drawings in the École des Beaux-Arts and the Chevrier-Marcille collection. The motifs derive from antique sarcophagi (e.g., the *Centaurs, Pan, the Maenads, and Satyrs,* Louvre, No. 286).

23. Stag Hunt; 1817.

Pencil with sepia wash and white heightening, 20 x 25.4 cm. Paris, Louvre.

Many motifs in this sheet are reminiscent of the hunting scenes on sarcophagi with the stories of Hippolytus, Adonis, and especially Meleager (see Carl Robert, *Die Antiken Sarcophagreliefs,* 1897 and later).

24. Horses Playing; 1816-1817; signed.

Black and red chalk, 20.4 x 26.8 cm. New York, Wildenstein Gallery.

This drawing, now first published, is loosely related to the *Race of Riderless Horses* (pls. 27, 28).

25. Mounted Herdsmen in the Campagna; 1816-1817.

Pencil and sepia wash, with white heightening, 20.7 x 27.8 cm. Cambridge, Massachusetts, Fogg Museum, Winthrop Bequest; from the Dubaut and Winthrop collections.

Such a work as this is transitional between single studies (see pls. 24 and 31) and the succeeding large compositions. For the inspiration from an antique source see the sarcophagus with the *Battle of Achilles and Penthesilea* (Louvre, No. 1052).

26, 27. Race of Riderless Horses on the Corso in Rome (C. 82); 1817.

Canvas, 42.5 x 59 cm. Baltimore, Walters Art Gallery; from the Couvreur and Walters collections.

Goethe had already allowed himself to be strongly impressed by one of the biggest and best shows of the Roman carnival, the racing on the Corso. Géricault's existing sketches and studies give us an excellent idea of the way in which the artist crystallized his vision from the first stock-taking sketches "with fifteen or twenty little horses" to the monumental scene with a single horse and four figures in ageless costume (pl. 29). Clément states that a "canvas of thirty feet" was left in Rome with the work hardly begun on it, and was later destroyed. More than twenty oil sketches and countless drawings show the project in various stages between the "real" and the "ideal" versions. Part of the material (five sketches and six drawings) was collected in an essay by Nancy Wynne (*Magazine of Art,* April, 1938). The scene portrayed in the Baltimore picture was the first stage of the crystallization: almost realistic, but with a handling anticipating Daumier's in the tribunes full of spectators.

28. Start of the Race of Riderless Horses (C. 85); 1817.

Paper mounted on canvas, 45 x 65 cm. Paris, Louvre; from the Camille Marcille and Jean Dollfus collections.

"This sketch of the greatest beauty," says Clément, "is highly developed, and seems to be the last that Géricault made. We may take it as the finished and final project for the picture that he had in mind." For the ancient type of horse, see the sarcophagus with the *Fighters and Amazon* (Louvre, No. 261). The Centenary Exhibition showed sixteen oils and drawings involved with this subject.

29. Capture of a Wild Horse (C. 87); 1817.

Canvas, 46 x 59 cm. Rouen, Musée des Beaux-Arts; from the Pillet and Couvreur collections.

Clément treats this picture as a special study, whose elements would probably be taken into the final painting of the *Race of Riderless Horses:* it is to be considered a *véritable tableau* (free-standing picture) and is not preliminary to any other sketch. The greatest names have been used in

comparisons which are to its credit, notably those of Poussin and the frieze of the Parthenon. Here again, the selfsame gestures may be studied from antique sarcophagi, e.g., the one with the *Labors of Hercules* (Louvre, No. 292).

30. Italian Landscape; 1816-1817.

Gouache on parchment, 16 x 20.8 cm. New York, Wildenstein Gallery; from the Coutan-Hauguet collection.

Clément describes under his catalogue No. 158 a drawing which is certainly not identical with this, but sounds similar in its features: "Wild landscape of great character. Very robust execution. Energetic and deep shadows."

31. Taming a Bull (C. 96); 1816-1817.

Pen and ink, 24 x 30.5 cm. Paris, Louvre; from the His de la Salle collection.

Even this motif comes from a late-classic sarcophagus: *Mithras and the Sacrifice of a Bull;* so did the Leda in a contemporary drawing (see Berger, *Géricault: Drawings and Watercolors,* pl. 15). Quite similar motifs are found in the sarcophagi with *Jason and Medea* (Louvre, No. 410) and with *Nereids Riding Sea-Colossi* (Louvre, No. 1634).

32. Subduing the Beeves (C. 95); painted in 1817, after the return to Paris, yet still stamped with the Roman approach to form.

Canvas, 56.5 x 48 cm. Cambridge, Massachusetts, Fogg Museum, Winthrop Bequest; from the Couvreur, Lamoignon, Duchesse de Galliéra, Pierre Dubaut, Duc de Trévise, and Winthrop collections.

Clément states that the work grew from such trivial motifs as could be picked up in the slaughterhouse in the Rue de la Pépinière.

III. Paris, 1817-1820.

33. Oriental Woman; about 1818.

Black and red chalk with sepia wash and white heightening, 20.8 x 13.3 cm. London, British Museum; from the His de la Salle collection; perhaps inspired by a piece of sculpture.

34. Bulldog (detail); about 1817-1818.

Panel, 81 x 62 cm. New York, Richard Goetz; from the Foinard collection.

Bulldogs were Géricault's favorite dogs; he owned one and painted many (cf. Clément, Nos. 74, 113). The detail reproduced is from one of the best-preserved paintings, and lets us see the rich brush-stroke of this period.

35. Head of a Soldier (C. 119); 1817-1818.

Canvas, 40 x 31 cm. Paris, Robert Lebel collection; from the Moreau-Nélaton, Richard

Goetz, and Duc de Trévise collections; painted, according to Clément, 1818-1820, according to Pierre Dubaut 1812-1815 (No. 29 in the Bernheim exhibition of 1937); but most probably dating 1817-1818, soon after the return from Italy.

36. Cats (C. 56); 1817-1818.

Pencil, 32 x 40 cm. Paris, Louvre; from the His de la Salle collection.

Most of the animal studies are dated in Clément's catalogue before the Italian journey, i.e., before 1816, while in his text (pp. 116 ff.) he gives "the months between the return from Rome and the beginning of the *Medusa*" as the period in which most of these works were created. They were made in the Jardin des Plantes in Paris, where Géricault sketched occasionally with Delacroix and the sculptor Barye. A related sheet in the Fogg Museum is reproduced in Berger, *Géricault: Drawings and Watercolors*, pl. 23.

37. Sprawling Cat; 1817-1818.

Canvas, 38 x 45 cm. Formerly Paris, collection of Baron Cassel; from the Champmartin, Richard Goetz, and Duc de Trévise collections.

In the firm modeling of its paint, this work shows nothing comparable to the standard method of its period; only in early Cézannes do we find similar tendencies.

38. Couple of Lions (C. 52); 1818.

Water color, 15 x 23.5 cm. Paris, Louvre; from the Hauguet collection.

The painter-like turn taken in the second Paris period, already recognizable in the *Bulldog* (pl. 34), is especially visible when these animal studies are compared to those of the Roman period (pls. 22-29, 31, and color pl. II).

39. Bed in a Stable; 1818-1819.

Canvas, 33 x 40 cm. Paris, private collection; from the collections of Richard Goetz and the Duc de Trévise.

Pierre Dubaut (Bernheim exhibition catalogue, 1937, No. 67) assigns this to the English period, 1820-1822; more fitly assignable to the previous French period, when chiaroscuro effect, fat brush-strokes, and generous diagonal forms are found together. Or does the work belong to the very latest period?

40. Blacksmith's Signboard (C. 112); 1818-1819.

Panel, 44.5 x 37 cm. Paris, private collection; from the Gobin collection; sketch for the actual signboard of a smith on the road to St.-Germain-en-Laye.

The painter had undertaken in his youth to paint a similar sign. The one reproduced seems, in its combination of realistic intensity, almost heraldic form, swinging motion, and saturated color, characteristic of his capabilities at the time when he was working on the *Medusa*.

41. Rescue of the Shipwrecked (from the *Medusa* cycle); 1818.

Black ink, heightened with white, 41 x 30.6 cm. Bayonne, Musée Bonnat; detail study for an unexecuted variant of the *Raft of the Medusa* which was to show the approach of the rescue vessel.

Such a scene is listed in Clément's catalogue as No. 101 among the paintings.

42. The Raft of the Medusa: first preparation (C. 98); 1818.

Canvas, 36 x 44 cm. Paris, Louvre; from the Schickler collection.

This first idea for the picture shows weighty differences from the final version; not only fewer figures but also a far looser grouping. The two signaling sailors on the right stand on the level of the raft, the more effective raising on barrels having not yet been thought of. The scene is perhaps more natural but less well-knit.

43. The Raft of the Medusa: second preparation (C. 99); 1818.

Canvas, 65 x 83 cm. Paris, Louvre; from the collections of Jamar, the Duchesse de Montebello, and Moreau-Nélaton.

This study, very close to the finished work, gives an unusual glimpse of the painter's method: when the composition was "set," he broke off painting in mid-process in order to save some verve and spontaneity for the big picture. Half the figures are unfinished, and the canvas can be seen naked except for pen drawing of the contours. Artistically this work seems to surpass the executed painting.

44, 45. The Raft of the Medusa (C. 97); 1818-1819.

Canvas, 491 x 716 cm. Paris, Louvre.

This work, which for almost a century was the sole vehicle of the artist's celebrity, is now (despite pious and respectful cleaning during World War II) in very defective condition. The bitumen content of some of the colors has caused corruption of broad areas of the surface, so that the paint film is darkened or destroyed. The general view is from a photograph made before 1900, Braun & Cie. kindly inform me, and it shows the picture still almost intact. The detail was photographed in 1950 and gives a good idea of the present state. In the Salon of 1819, where the exhibition of the picture caused a public scandal, it was ranked in eleventh place, says Clément, for the prize. At Géricault's posthumous auction on 2 November 1824 it was bought for 6,005 francs by his friend Dedreux-Dorcy, and ceded to the Louvre for the same price.

The artist, after long vacillation between the revolt of sailors against officers (pls. 46, 47) and the rescue of the shipwrecked by a gunboat (pl.

41), settled at last on the drifting raft with the rescue ship on the horizon. Clément knew three composition sketches (pls. 42, 43), all of which lack the figure of the young man in the right foreground, because the latter was added to the great canvas at the last moment. Altogether, forty-nine paintings and drawings connected with the *Medusa* were known to the writer of the basic monograph; it would be highly interesting to see them all carefully gathered together.

46. Mutiny on the Raft of the Medusa (C. 109); 1818.

Pen and ink, 41.5 x 59 cm. Amsterdam, Gemeente Museum; from the Ary Scheffer, Fodor, and Lamme collections; first design for the (later discarded) episode of the shipwreck.

This and the following almost unknown studies for the mutiny scene deserve an appreciation of their great quality, strength, and freshness. A more summary sketch is in Rouen. A connoisseur will see in more than one of these figures, just as in the executed painting, motifs which derive from antique sarcophagi but may have come to Géricault through the study of Michelangelo. For the recumbent figures see the sarcophagus with a *Battle of Amazons* in the Capitoline Museum and the following in the Louvre: *Fall of Phaeton* (No. 425), *Murder of Clytemnestra* (No. 380), *Adonis* (No. 347); for single groups see Michelangelo's cartoon for the *Battle of Cascina.*

47. Mutiny on the Raft of the Medusa (C. 110); 1818.

Gouache, 40 x 51 cm. Cambridge, Massachusetts, Fogg Museum, Winthrop bequest; from the Hulot and Winthrop collections; variant of pl. 46.

"A motif of fright and horror, a real nightmare" has here, in Clément's words, become a picture. It was not suited for further transformation into a painting, but as a drawing it is one of the pinnacles of Géricault's art.

48. Negress (C. 127); 1818.

Canvas, 39 x 31 cm. Bayonne, Musée Bonnat; from the His de la Salle collection.

Study for the *Medusa,* but not used in the final version.

49. Head-Study for Mutiny on the Raft of the Medusa.

Water color, 49 x 38 cm. Paris, collection of Maître Alphonse Bellier; from the Duc de Trévise's collection.

This study is for a figure to the right of the mast (see pl. 47), inspired by a plague victim in a painting by Doyen in St.-Roch, Paris. This circumstance reveals how many inspirations and influences the painter of the *Medusa* was open to; critics have great trouble in making the list complete. Clément notices in the coloring a more explicit similarity to Cara-

vaggio, the Bolognese, and Jouvenet, a fellow-countryman working in the time of Louis XIV. He adds that certain figures are borrowed from Gros and Guérin. Rosenthal is reminded of Michelangelo's *Last Judgment.* Oprescu sees, besides, echoes of Girodet's *Deluge,* of Prud'hon's *Crime Pursued by Justice,* and of Guercino. Walter Friedländer even feels that Géricault wished to provide in the *Medusa* a pendant to Gros's *Napoleon Visiting the Plague-Stricken at Jaffa.*

50. Head of a Negro; 1818.

Stumped black chalk, 24.5 x 17.2 cm. Paris, Pierre Dubaut collection.

Study for the Negro by the mast in the *Raft of the Medusa.* A series of other Negro heads from this period (see pl. 48) was not used in the final picture. See also an oil study of a Negro at Châlon-sur Saône. In 1798 Girodet had already aroused great excitement with a life-sized portrait of a Negro Deputy from Santo Domingo.

51. Head of a Corpse.

Canvas, 37 x 30.5 cm. Geneva, Musée d'Art et d'Histoire. On the back of the frame an inscription: "Tête de Jacques Didier exécuté en 1821 (?) pour avoir tué sa femme."

The picture must belong to the series of *Medusa* studies. But in 1821 Géricault was in England. Faced with the choice of doubting the genuineness of either the painting or the inscription, some critics have chosen the first alternative; but the second seems more acceptable, for I do not know of any other painter who could have made such a picture, and it has many marks of Géricault's style. Or could this be a close contemporary copy? I have not seen the original.

52. Head of a Guillotined Man; 1818.

Canvas, 46 x 56 cm. Chicago, The Art Institute (A. A. Munger collection, McKay fund); from the Champmartin, Foinard, and Richard Goetz collections.

One of the *Medusa* studies, but not used in the picture; related to the Stockholm study (color pl. III) and to others in the Squire, Prager, and Dubaut collections.

53. Still-Life with Arms and Feet (C. 108); 1818.

Canvas, 52 x 64 cm. Montpellier, Musée Fabre; from the Jules Claye and Bruyas collections.

Preparatory to the *Medusa,* but not used in the big painting. "In its painter-like execution, this is one of the most beautiful pieces Géricault painted" (Clément). Robert Lebel owns a counterpart painted by daylight.

54-59. The Fualdès Story (C. 165); 1818?

54. Fualdès Abducted into Bancal's Brothel.

Pen and wash, 19 x 26 cm. American private collection; from the **Constantin,** Lehoux, Moignon, and Duc de Trévise collections.

55. **Fualdès Murdered.**

Pen and wash, 19 x 28 cm. Same ownership.

56. **The Murderers Drag Fualdès' Body to the Aveyron by Night.**

Pen, 19 x 27 cm. Same ownership.

57. **Variant of pl. 56.**

Water color, 21.5 x 29 cm. Lille, Museum.

58. **Fualdès' Body Thrown into the River.**

Pen and wash, 19 x 27 cm. Same ownership as pls. 54-56.

59. **The Murderers Making Off.**

Pen and wash, 20.2 x 26.2 cm. Rouen, Musée des Beaux-Arts.

This famous series is here reproduced in full for the first time. Clément had heard of only "three or four compositions" and dated them all in the last period, 1823, though the trial took place in 1817 and the picture-sheets which scared Géricault off appeared at the same time. Probably the Fualdès series belongs to the same time as the conception of the *Medusa,* not before. That picture, as we know, appeared three years after the event. On stylistic grounds the Fualdès suite cannot be placed too early, certainly not in 1817, as Courthion insists.

The motifs are reminiscent in detail of a Raphael drawing (*Death of Adonis?* Fischel No. 97), for which Middeldorf rightly assumes a source in classical reliefs. Géricault went straight to the source, namely to groups from the following antique sarcophagi in the Louvre: *Burial of Hector* (No. 353), *Orestes and Iphigenia* (No. 1607), the *Achilles Legend* (No. 2120). Géricault had already drawn the motif of Hector's corpse from a sarcophagus before 1814 in the Zubaloff Sketchbook (fol. 1; see note on fig. 8).

60. **Colonel Bro as a Child (C. 126); 1818-1819.**

Canvas, 60 x 49 cm. American private collection; from the Bro de Comères and the Duc de Trévise collections.

Dominique-Louis-Olivier Bro was born, according to his father's memoirs (p. 136), on 19 December 1813; he was apparently four and a half or five when this picture was painted. About the same time a considerable series of other portraits of boys was made (Metropolitan Museum, Museum of Le Mans, and H. P. Hill collection, New York).

61. **Prize Fight (D. 10); dated 1818.**

Lithograph, 35.2 x 41.6 cm. Only twelve impressions known.

This astonishing sheet is most probably inspired by a sporting print, and reminds us again that Géricault was interested, long before his English journey, in British subjects and works of art, which he could have seen in the studio of his first teacher Carle Vernet. An early copy of his *after* Stubbs points in the same direction. In an assembled volume of Géricault drawings (Chicago, The Art Institute) there are many careful pencil drawings for the boxers, which Barye the sculptor later copied (Baltimore, Walters Gallery). Further boxing sketches from the English period are in Bayonne (see fig. 3).

62. Mounted Artillery (D. 16); 1819.

Lithograph, 30 x 38.5 cm. Only six impressions known.

The late date is interesting above all: it shows that the undertaking of the *Medusa* had not wiped out the military material or resource, and that it is not permissible to mark off one period from another by content alone, as is often done in Géricault's case. Military subjects occur, especially in lithographs, until the last year, 1823.

63. Battle with Death (C. 163); 1820 or earlier.

Pen and wash, 17.5 x 24 cm. Berg am Irchel, Switzerland, Hans E. Bühler collection; from the Sauvé, Éd. Arago, Jules Ferry, and Duc de Trévise collections. According to Clément 1822-1823, according to Dubaut before 1812, according to Gobin before 1816; perhaps they confused this with another drawing (C. 89) of the same subject. The latest possible dating seems to me to be just before the English journey, therefore 1820.

IV. England, 1820-1822.

64. London Physiognomies; 1820-1821.

Pencil, 22.4 x 15.8 cm. Paris, École des Beaux-Arts; from the Armand-Valton collection.

The same collection includes two similar sheets which apparently come from the same sketchbook. This piling-up of faces which pass from "characters" to caricature make it almost certain that Géricault must have seen the subscription ticket for Hogarth's print series, *Marriage à la Mode,* 1784. The inclusion of the "line of beauty" in the lower right corner tends to confirm this.

65. Fishmonger (right half of the sheet); 1820.

Pencil, 20 x 28 cm. Paris, Pierre Dubaut collection; from the De Brack collection.

A revision of the lithograph D. 24, which had retained too many traces of the collaboration with Charlet, in other words seemed too journalistic and lacking in form.

66. Horsewoman; 1820-1821.

 Pen, 25.5 x 20.5 cm. Providence, Rhode Island, Danforth collection; from the collections of Eugène Delacroix, Jenny Le Guillau, Constant Dutilleux, and A. A. Préault.

 Study for the painting C. 139. The unusual broad hatching and the dabs of wash must be traced to the influence of British drawing style, which (after an initial dislike) began to interest the artist hugely. Was he acquainted with Romney's drawings?

67. Pity the Sorrows of a Poor Old Man! (D. 31; detail); 1821.

 Lithograph, 31.7 x 37.6 cm.

 Detail from the only known example of the first state, in the Cabinet des Estampes, Paris. Called by Béraldi "a masterpiece of Géricault and of all lithography." One of a series of twelve sheets published in London by Hullmandel and known as the large English series.

68. Hanging (C. 140); 1821.

 Pencil with brown ink wash, 40 x 32 cm. Rouen, Musée des Beaux-Arts; from the Lehoux collection.

 A new technique for the artist, this mixture of pencil with areas of wash, though derived from a late 17th century chalk-and-wash technique used by LeBrun and others, was an approach to the English way of using water color.

69. Flemish Farrier (D. 33); 1821.

 Lithograph, 23 x 31.5 cm.

 One of the most popular sheets, much imitated; belongs to the Hullmandel series. Géricault made many drawings and perhaps a small oil study (genuine?) for it.

70. The Paralytic Woman (D. 38); 1821.

 Lithograph, 22.5 x 31.7 cm. The rarest sheet of the English series, titled A PARA-LEYTIC [*sic*] WOMAN.

 "It is unbelievable how quickly Géricault penetrated the English character," writes Clément, "and nothing tells us more about his power of adaptation than these admirable prints." Géricault himself was somewhat more restrained in appraising these works. In a letter from London he mentioned the "inconceivable rage" for lithographs, and continued: "I flatter myself that they are only a sort of shingle that I hang out, and that the taste of true art-lovers who have been thus attracted will soon call me to more worthy work."

71. Plowing in England; 1821-1822.

 Water color, 32.2 x 49.4 cm. Schloss Berg am Irchel, Switzerland, Hans E. Bühler collection; from the collection of Pierre Dubaut.

The water colors of the English period, in which the loosening of the style is most noticeable, were unknown or little known to all the biographers; six were shown at the Centenary Exhibition, and were a revelation. I published eight in the book *Géricault: Drawings and Watercolors.*

72. Entrance to the Adelphi Wharf (D. 40); 1821.

 Lithograph, 25.5 x 31 cm.; part of the large English series.

 Innumerable pencil drawings for this sheet exist: each of the horses seen from the front, back, and sides, details of harness, hoofs, etc.

73. Jockeys at the Gallop; 1821.

 Canvas, 25 x 37 cm. Bayonne, Musée Bonnat; from Léon Bonnat's collection.

 An unfinished variant of the *Epsom Derby* (pl. 74); here the leg action of the galloping horses is more "correct"; this shows that Géricault's deviations from what we know for fact, and from what appeared as fact to the eyes of 1820, are not due to any deficiency of observation, but only to the artist's intent and desire. Three rather feeble variants, none of them completely genuine, are in the Louvre.

74. Epsom Derby (C. 134); 1821.

 Canvas, 91 x 124 cm. Paris, Louvre; from the Chérubini, Laneuville, and Couvreur collections.

 A sporting print of 1816, "Sir Joshua Beating Filho da Puta at Newmarket," by James Pollard (see fig. 7), supplied the motive and many details, including the much-discussed "flying" horses, but of course none of the almost Impressionist atmosphere or the modern vision of the artist. An oil study of one of the jockeys is at Wildenstein's in Paris; and the author owns a sketch of preparations for the Derby.

75. Coal Wagon with Five Horses; 1821.

 Brush, 17.2 x 26 cm. Basel, private collection.

 A somewhat altered study for the lithograph D. 36. Cf. also the painting C. 141, of which we know variants in Mannheim and Philadelphia. The theme of a coal wagon with three, five, or seven horses, and the related theme of the mail-coach, became two of the *leitmotifs* of the English period. It would be interesting to assemble the two dozen drawings, water colors, lithographs, and paintings, and to draw up from them in plain sight a sort of grammar of the "open English" style.

V. Paris, 1822-1823.

76. Coal Wagon with Seven Horses; 1822, immediately after the return to France.

Pencil and wash, 17 x 27 cm. Cambridge, Massachusetts, Fogg Museum, Winthrop bequest; from the Rollin, Dubaut, and Winthrop collections.

On circumstantial evidence—because a Thames bridge (?) is visible in the background, and the harness and driver's costume are English—Agnes Mongan (*One Hundred Master Drawings,* Cambridge, 1949, p. 144) calls this a product of the English period. Stylistic arguments seem to us, however, weightier than those of motif or topography. The division of the "English" works from the more complex ways of seeing of the last year is of basic importance for understanding the late development of the artist, which took place in so short a time. Géricault himself pointed out the difference. When some of his "English" lithographs were reworked for a later French edition by his collaborators Léon Cogniet and Volmar, he admonished them "to bring out the whites more from their dark surroundings and to strengthen the shadows, in order to give the work more freedom and richness. The light [previously] was too diffused" (Clément, p. 221). In other words, he wants more firmness, accents which shall create order, and solid structure. All this is recognizably present in the sheet reproduced, in the strengthening pencil contours, the insistent horizontal movement, the sharp accents (much darker than "natural" in value) in the dark areas of wash. The drawing thereby separates itself from all "English" works of similar theme, and must be considered a revision of them made from a later viewpoint.

77. Wine-Barrel Cart (C. 96); about 1822.

Canvas, 58 x 72 cm. Providence, Museum of Art of the Rhode Island School of Design; from the Dr. Biète, Delessert, O. Freund, and R. Millman collections. According to Clément 1817-1818, before the *Raft of the Medusa;* the color and the type of horse agree rather with the time after the English visit.

78. Scene from the Greek War of Independence (C. 149); 1822-1823.

Canvas, 36 x 44 cm. Luzern, art market; from the Leconte and Dubaut collections.

Clément gives a long description of the picture without being able to unravel the meaning. Another title is *The Plague-Stricken.* Important as the only painted subject-picture of the last period; the color accents are white (in the wrappings of the woman in the foreground), red (headdress of the man in the second plane), green with reddish shadows (in his cloak), flesh-color and red (in the half-naked figure), again green (in the stretched-out figure with hands raised to heaven), and finally blue (in the figure with its head between its hands); over this plays a scale of tones which runs from impenetrable dark at the right to the palest transparency.

This is, then, a complicated system, which nevertheless corresponds well with the "open" form of this period.

79. **March of the Turkish Army on the Shore; 1822-1823.**

Pen and wash, 21 x 27 cm. Paris, Robert Lebel collection; from the Baron Schwiter, Richard Goetz, and Duc de Trévise collections.

This drawing, with its rhythmic, atmospheric, and realistic qualities, has been praised as an anticipation of the artistic tendencies of a half-century later, and as an inspiration for Constantin Guys, "the painter of modern life" (Baudelaire).

80. **Madame Bro (C. 125); 1822?**

Canvas, 45 x 55 cm. Paris, Bro de Comère collection. Clément surprisingly gives "between 1818 and 1820" as the date, whereas the color points to the last period. Only then does the whole order of sensitivity and delicacy, otherwise foreign to Géricault, get its chance; only at this time, when so many new doors open to him.

If the costume suggests the Biedermeier a little, the handling of the landscape, the cashmere shawl on the chair-back, and the hat and veil foretell the Ingres and Degas of the 'sixties.

81. **Louise Vernet as a Child; 1822.**

Canvas, 60.5 x 50 cm. Paris, Louvre; from the collection of Madame Delaroche-Vernet; the sitter, daughter of Géricault's friend Horace Vernet, was then eight years old.

The newly aroused interest in the sculptural character of the human body appears here for the first time since the English period.

82. **Negro Soldier with Lance (C. 175 bis); 1822-1823.**

Brush and sepia and gray over pencil, 33.5 x 24.9 cm. Cambridge, Massachusetts, Fogg Museum; from the De l'Aage, Marmontel, Beurdeley, and P. J. Sachs collections.

"Géricault and Delacroix . . . were the outstanding exponents of the Romantic Movement, turning from Greek and Roman legends and history to contemporary events, as well as to subjects of mediaeval literature or oriental life. . . . Géricault had many costumes, collected on his travels in North Africa." So runs the comment on this drawing in *The Pocket Book of Great Drawings* by Paul J. Sachs (New York, 1951, p. 96). The usual popular pairing of the two painters has here gone so far that they have been exchanged. Géricault was never in Africa; nor did he abjure classical motifs, but filled contemporary events with them. He shared his "Orientalism" with the school of David, and he drew from many other sources. Delacroix, on the contrary, painted only one contemporary event (the *Barricade*) in his long life.

83. **Negro on Horseback (C. 175); 1823.**

Brush drawing, on brown paper, 21 x 26 cm. Berg am Irchel, Switzerland, Hans E.

Bůhler collection; from the Marcille, Marquis de Valori, and Delteil collections; painted in 1823 along with other Orientalia; see also the lithograph of the *Giaour* (D. 95).

Although the dimensions of the drawing are slightly at variance with those listed by Clément, I believe in its authenticity. It is as if this work were a revision of the *Chasseur Officer* (pl. 2) after the experiences of the three intervening phases of style.

84. Lion Hunt; 1822-1823.

Water color, 32.2 x 40.5 cm. Cambridge, Massachusetts, Fogg Museum, Winthrop bequest; from the A. Vacquerie and Winthrop collections.

With this work Géricault anticipates by about ten years the great wave of Orientalism in French painting. Decamps, Marilhat, Champmartin, Delacroix, and Chassériau sail in his wake; Barye, the sculptor and first-class master of water colors and gouaches with animal subjects, studies and copies Géricault. It is highly characteristic that the latter, who stood so near Rubens at an early period, now avoided Rubensian color. It was Delacroix's lion and tiger hunts that reanimated the Orient with the palette of the great Fleming.

85. Liberation of Victims of the Inquisition (C. 161); 1823.

Pencil and red chalk, 42 x 58 cm. Paris, Pierre Dubaut collection; from the Alexandre Colin and Binder collections; design for a picture "of colossal dimensions."

A smaller pencil drawing with detail of one motif is in the same collection.

86. The Slave Trade (C. 160); 1823.

Pen, 10.5 x 13.5 cm. Bayonne, Musée Bonnat; from the Valferdin and Léon Bonnat collections; design for an unexecuted painting of vast size; variant of pl. 87.

The freeing of Negroes, the legal abolition of slavery, for which a plea is made here, took place in France in 1848, in the United States much later. The theme of the slave trade appears first in British painting with Morland.

Three smaller pencil drawings with minor changes, in Pierre Dubaut's collection, show that the project at least passed beyond the first hasty design. It is noteworthy that here there is a renewed dependence on classical inspiration, not on the Romantic.

87. The Slave Trade (C. 159).

Pencil and red chalk, 30.7 x 43.6 cm. Paris, École des Beaux-Arts; from the His de la Salle collection.

88. Landscape with a Limekiln (C. 154); 1822-1823.

Canvas, 50 x 61 cm., signed. Paris, Louvre; from the Jamar, Ferol, and Mosselman collections.

One of the trail-blazing works of the last period, in which the most varied tendencies of the painter are happily united. There is a coastal landscape in Brussels, called *Wreckage,* which probably belongs, too, to this last period; it is predominantly dark-toned.

89. Negro; 1822-1823.

Canvas, 71 x 61.5 cm. Buffalo, New York, Albright Art Gallery; from the Otto Ackermann collection; Régamey first published and dated the picture.

There is a wash drawing of *Two Negroes in Oriental Costume* in Pierre Dubaut's collection; it dates from the same time.

90. Man from the Vendée; 1822-1823.

Canvas, 71 x 58 cm. Paris, Louvre.

Though related stylistically to the pictures of the mentally ill (pls. 91-94, color pl. IV), this work is not of that series (see R. D. Solange, *"Le Portrait du Vendéen par Géricault"* in *Bulletin des Musées de France,* 1938, No. 4).

91. Kleptomaniac (C. 157); winter, 1822-1823.

Canvas, 60 x 50 cm. Ghent, Museum; from the collections of Dr. Lachèze, Charles Jacque, and P. A. Cheramy.

This and the following three pictures, as well as that shown in color plate IV, are the existing works from a series of ten, which were created on commission from the well-known Paris alienist, Dr. Georget. It is not clear just what was the purpose of these representations of typical insane cases; if they were to be illustrations for a new edition of Georget's book, *De la Folie,* which had first appeared in 1820, it is hard to see why lithographs or drawings were not made, rather than paintings. Furthermore, the portraits certainly do not coincide with the basic cases posited in the book. Therefore I should prefer to see in these relatively large pictures the intention of supplying illustrative material for the students and assistants of Dr. Georget. It was the goal of his theories to make it possible to draw conclusions about psychic illnesses from facial traits and from changes in physical appearance, especially in the face. In the presence of these paintings the learned man could have gone more profoundly into their pathology than in the presence of the patients. Although Georget's "organic" theories are held to be superseded, his clinical descriptions are today still considered masterpieces (see Gregory Zilboorg, *A History of Medical Psychology,* New York, 1941, pp. 390 ff.; also Margaret Miller, "Géricault's

Paintings of the Insane" in *Journal of the Warburg and Courtauld Institutes,* London, 1940-1941, vol. IV, pp. 151 ff.). A case doubtless similar to that represented in our pl. 91 is described by Dr. Georget as follows: "Every function is interrupted when the illness takes control and a crisis comes; the skin ceases to function as an evaporator, it dries and is warm in uneven spots, or it grows cold."

92. Insane Kidnapper (C. 156); winter, 1822-1823.

Canvas, 65 x 54 cm. Springfield, Massachusetts, Museum of Fine Arts; from the collections of Dr. Lachèze, Charles Jacque, Richard Goetz, and the Duc de Trévise.

Dr. Georget describes a similar case: "The acute attack is always accompanied by excitement and rush of blood to the brain. . . . The face flushes over the cheekbones. The more or less disfigured face varies in its expression, depending on the character of the ideas which are disquieting the spirit of the sick man." See also pl. 91.

93. Insane Woman (Gambler) (C. 158); winter, 1822-1823.

Canvas, 77 x 64 cm. Paris, Louvre; from the collections of Dr. Lachèze, Charles Jacque, and the Duc de Trévise.

The color is quite subdued here, as in the rest of the series; the predominantly brown tones are reminiscent, in the great richness produced with slight means, of Rembrandt or the young Tintoretto. See also pl. 91.

94. Insane Woman (Envy; C. 159); winter, 1822-1823.

Canvas, 72 x 58 cm. Lyon, Museum; from the collection of Dr. Lachèze.

Another quotation from Dr. Georget is almost like a description of this picture: "The circulation grows livelier, the pulse rate rises, the arteries in the neck throb strongly; the eyes glitter and are bloodshot." See also pl. 91.

Sculpture

95. Satyr and Nymph (C. 3); probably about 1818.

Bronze, height 29 cm. Paris, collection of L. Rollin; from the Duc de Trévise collection. Bronze cast from the only sculpture by Géricault as yet recovered, which is cut in "common" stone. The stone version (from the Thea Sternheim collection), because of the artist's lack of technical experience, is markedly inferior to the present version.

The work also goes by the name of *Jupiter and Antiope,* and is connected through a series of drawings (many in Pierre Dubaut's collection) with the well-known painting by Correggio. Another sculpture, lost since 1867, turned up recently, and has gone to the Albright Art Gallery in Buffalo, New York. It is a rape scene in unbaked clay (C. 5), a work which attractively combines technical artlessness with the highest plastic power.

INDEX

Works of Géricault are indexed under "Works," with abbreviations *P* (painting), *D* (drawing), *G* (gouache), *L* (lithograph), *S* (sculpture), and *W* (water color).

PLATES

ACKNOWLEDGMENTS

The author and the publisher express their thanks to the owners of paintings and drawings who kindly made photographs available.

Photographs and color-separation negatives from other sources are listed below:

Archives Photographiques, Paris: figs. 3, 4, 5, 6, 8, and pls. 1, 4, 5, 6, 20, 23, 38, 41, 48, 49, 73, 85, 86, 88 — Braun & Cie., Paris: pls. 43, 45, 61, 69, 70 — F. Bruckmann, Munich: pl. 89 — J. E. Bulloz, Paris: pls. 59, 90 — Galerie Charpentier, Paris: pls. 12, 13, 40, 75, 80 — Dr. Walter Gernsheim, London: pl. 15 — MM. Giraudon, Paris: pls. 2, 21, 28, 29, 31, 36, 37, 42, 62, 64, 74, 78, 87, 93, 94 — Hans Hinz, Basel: color pl. III — A. C. L., Brussels: pl. 91 — J. L. H. Muller, Paris: pls. 19, 44, 67 — MM. Neurdein, Paris: pl. 8 — Charles Uht, New York: pl. 16 — MM. Vizzavona, Paris: pl. 9 — Fig. 7 is reproduced from Frank Siltzer. The Story of British Sporting Prints, London 1929.

Color plates II and IV have been newly made for this work from the original paintings.

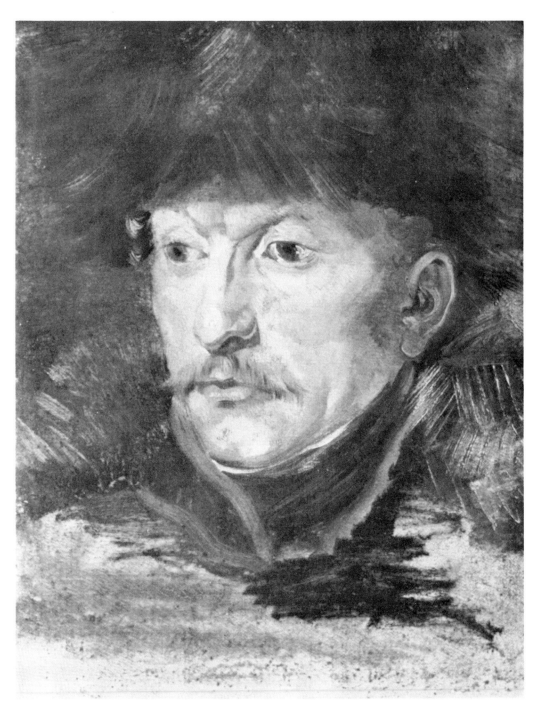

1. Lieutenant Dieudonné (portrait study for the officer in pl. 2)
Bayonne, Musée Bonnat

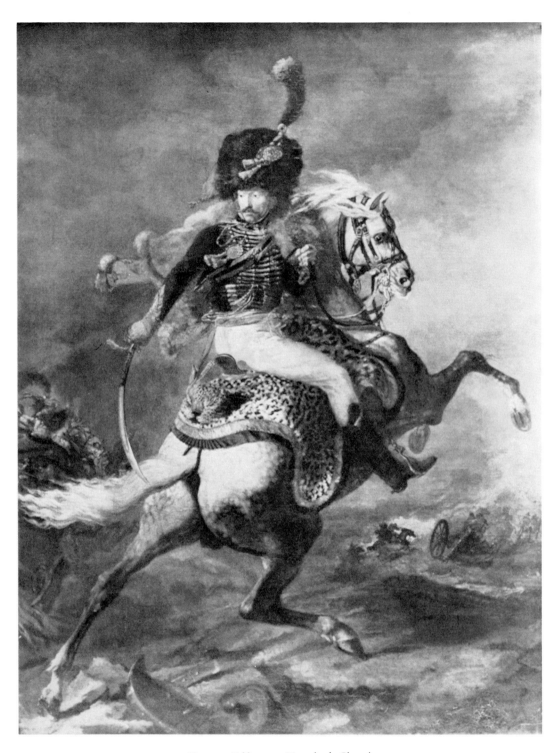

2. Chasseur Officer on Horseback Charging
Paris, Louvre

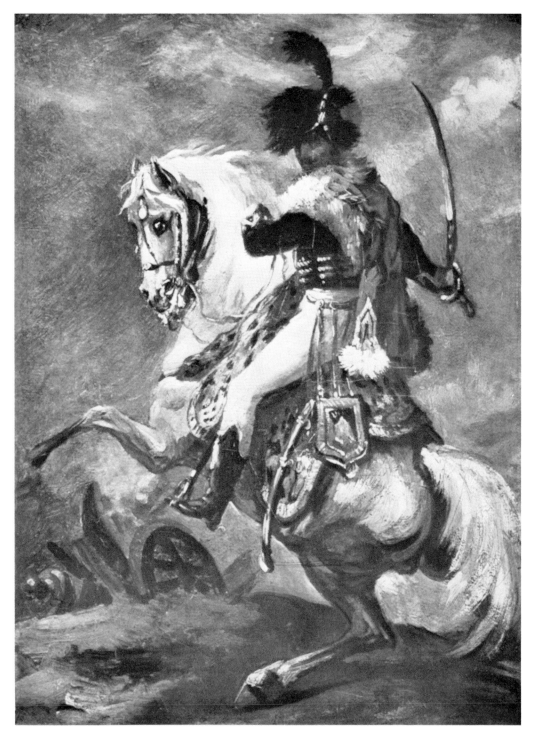

3. Chasseur Officer on Horseback Charging
Providence, Museum of Art of the Rhode Island School of Design

4. Bayonet Fight with Mamelukes. Paris, Louvre

5. Horse and Frightened Officers. Bayonne, Musée Bonnat

6. Horse Rumps. Paris, collection of the Vicomtesse de Noailles

7. Horse Frightened by Lightning, London, National Gallery

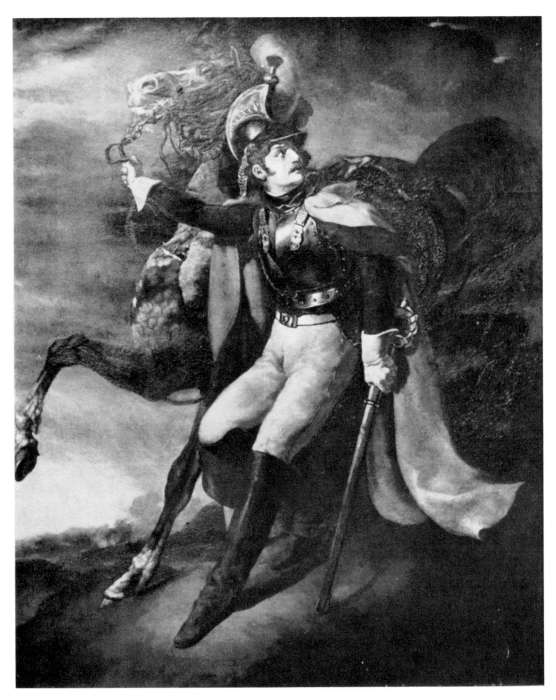

8. Wounded Cuirassier Leaving the Field
Paris, Louvre

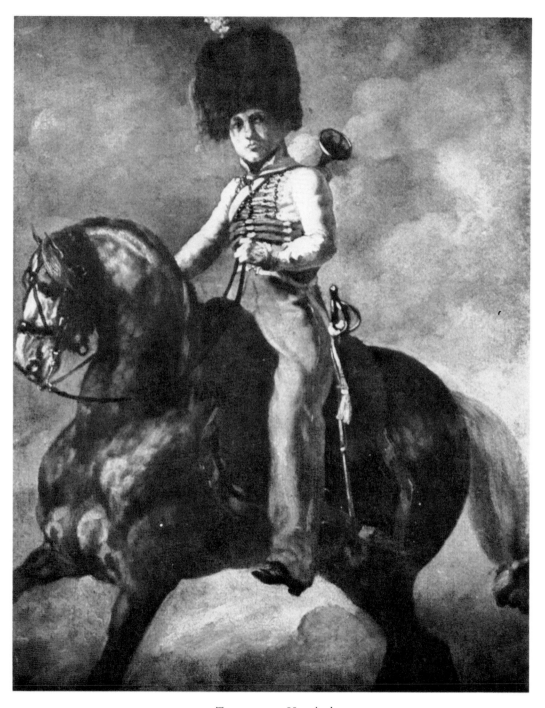

9. Trumpeter on Horseback
Hollywood, California, collection of Edward G. Robinson

10. Detail from pl. 11

11. Artillery Attack. Munich, Bayerische Staatsgemäldesammlungen

12. Carabinier
Rouen, Musée des Beaux-Arts

13. Veteran
Paris, collection of Aimé Azam

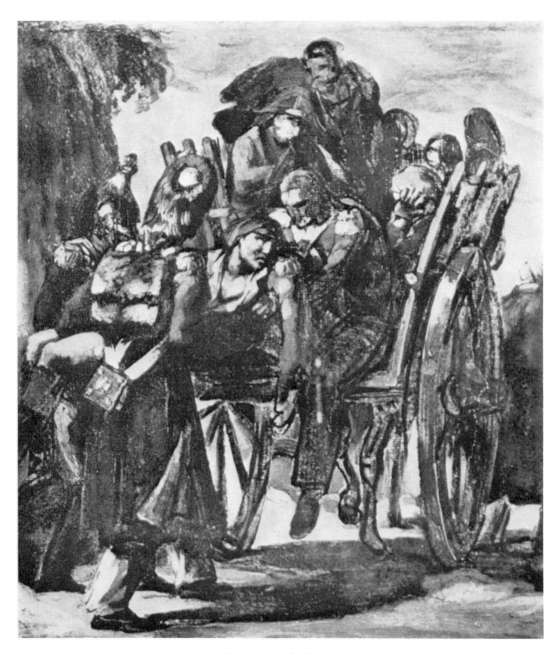

14. Wagonload of Wounded
London, collection of John Hugh Smith

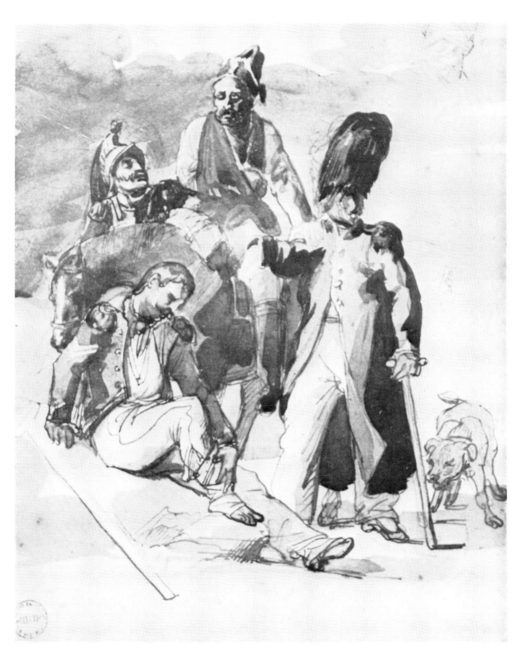

15. Scene from the Retreat from Russia
Rouen, Musée des Beaux-Arts

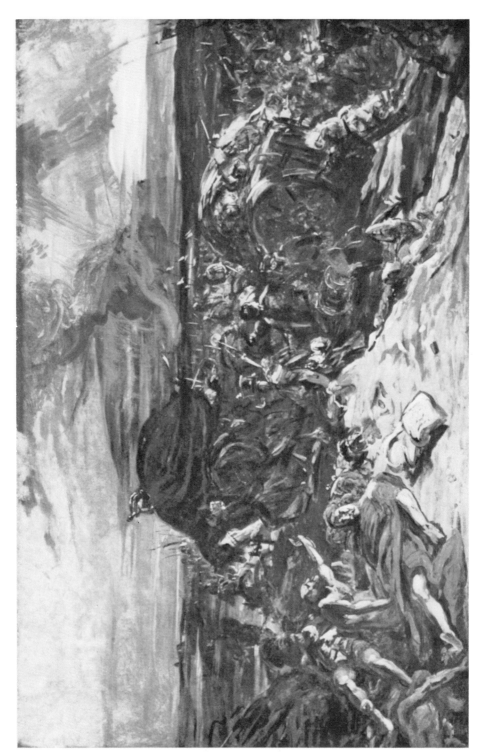

16. Retreat from Russia. New York, collection of Germain Seligman

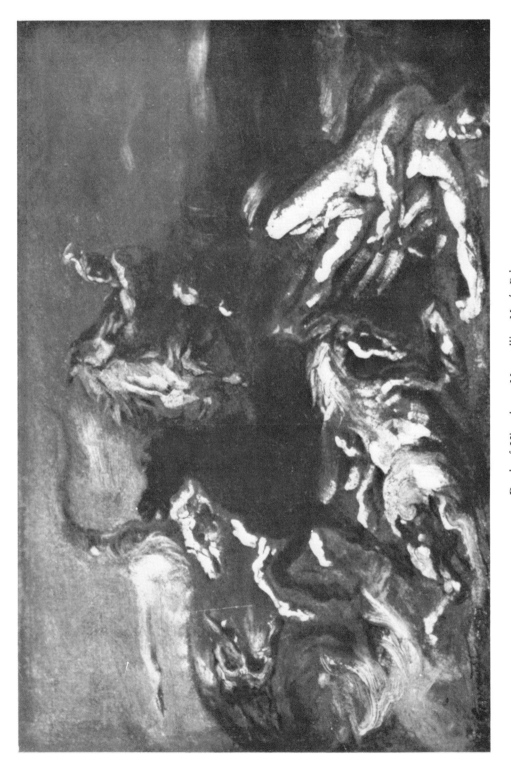

17. Death of Hippolytus. Montpellier, Musée Fabre

18. Detail from pl. 17

19. Lovers (detail). Geneva, collection of Dr. F. Firmenich

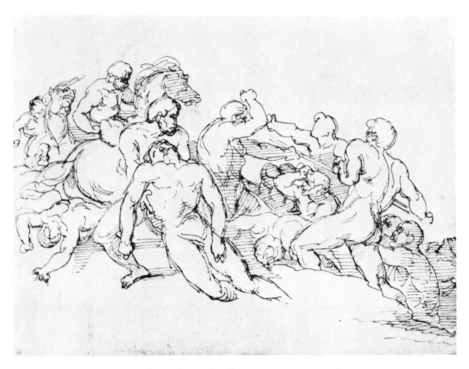

20. Battle of Cavalry and Infantry. Bayonne, Musée Bonnat

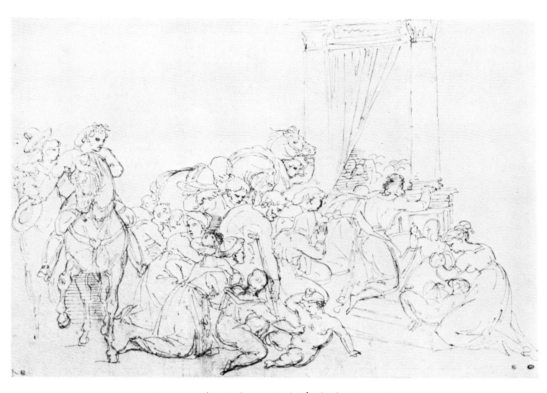

21. Prayer to the Madonna. Paris, École des Beaux-Arts

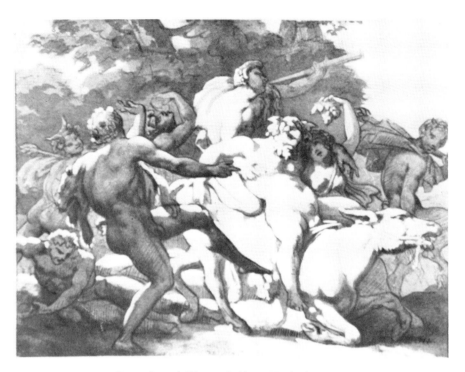

22. Procession of Silenus. Orléans, Musée des Beaux-Arts

23. Stag Hunt. Paris, Louvre

24. Horses Playing. New York, Wildenstein & Co.

25. Mounted Herdsmen in the Campagna. Cambridge, Massachusetts, Fogg Art Museum, Winthrop Bequest

27. Race of Riderless Horses on the Corso in Rome. Baltimore, Walters Art Gallery

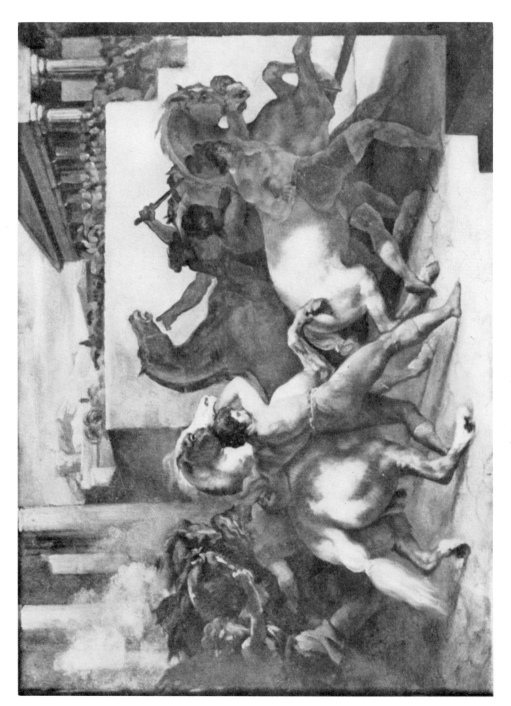

28. Start of the Race of Riderless Horses. Paris, Louvre

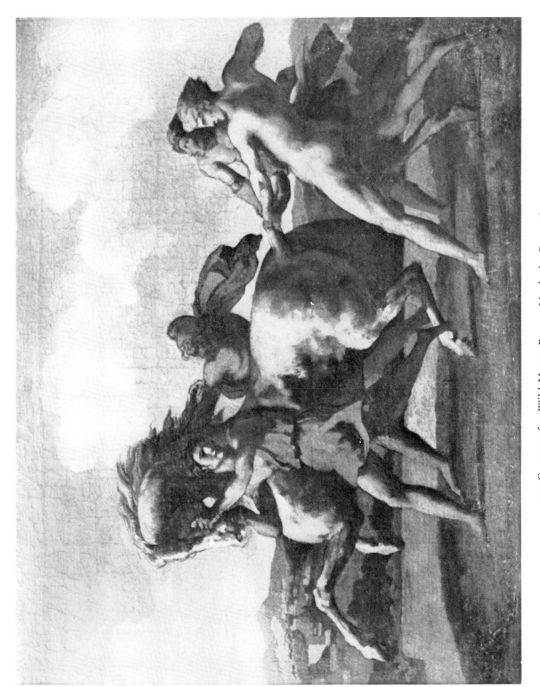

29. Capture of a Wild Horse. Rouen, Musée des Beaux-Arts

30. Italian Landscape. New York, Wildenstein & Co.

31. Taming a Bull. Paris, Louvre

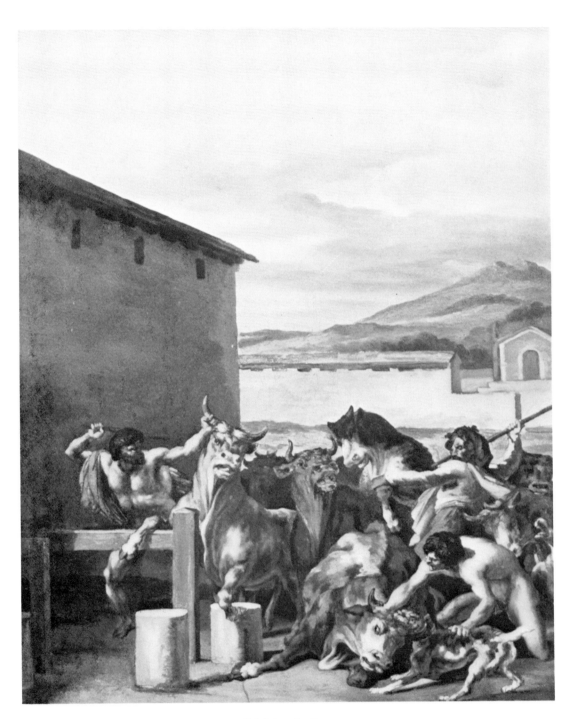

32. Subduing the Beeves
Cambridge, Massachusetts, Fogg Art Museum, Winthrop Bequest

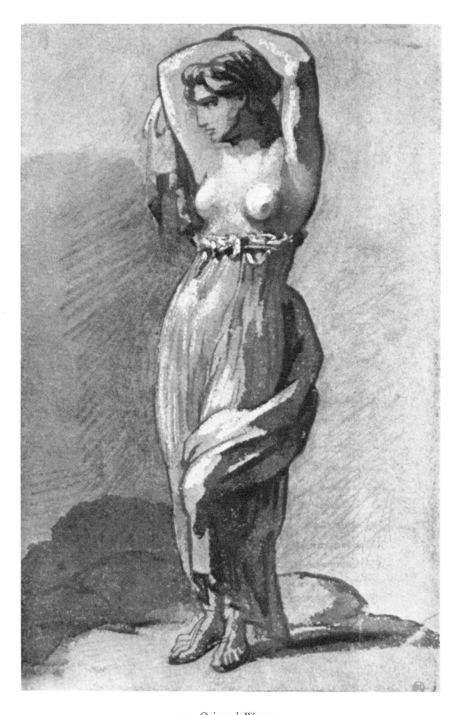

33. Oriental Woman
London, British Museum

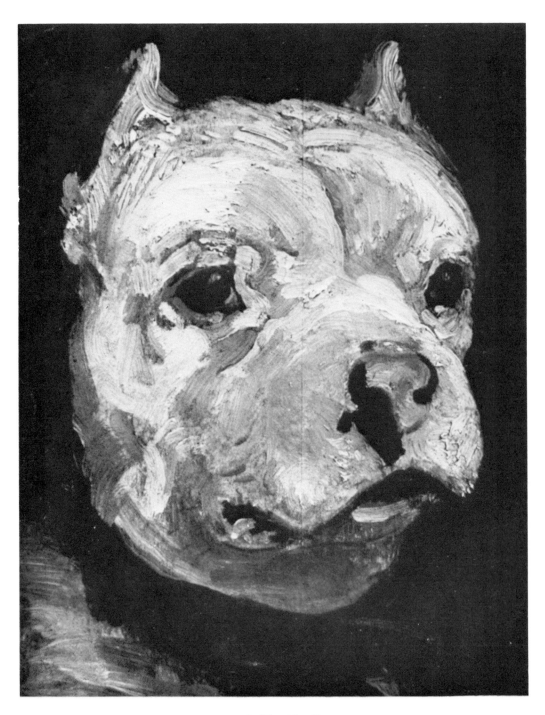

34. Bulldog (detail)
New York, collection of Richard Goetz

35. Head of a Soldier
Paris, private collection

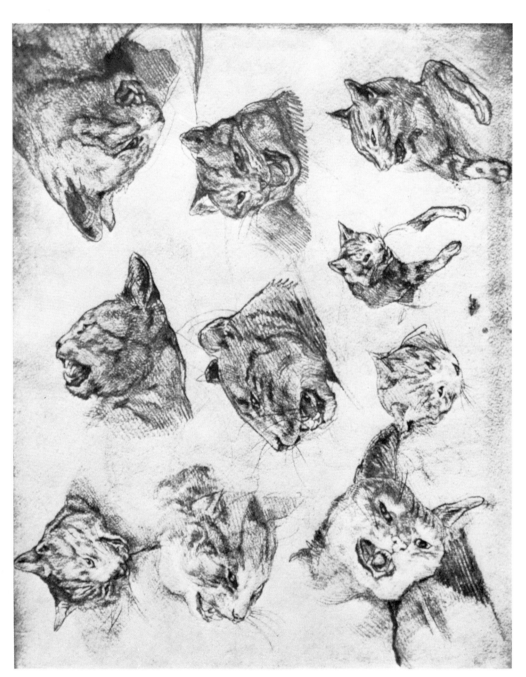

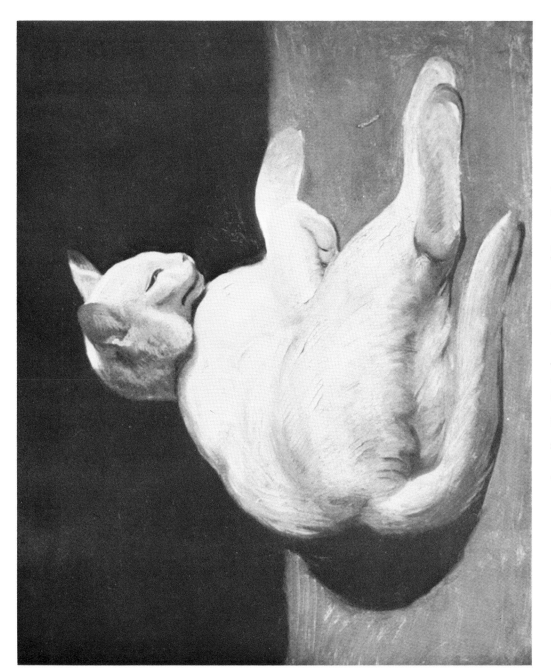

37. Sprawling Cat. Paris, formerly collection of Baron Cassel

38. Couple of Lions. Paris, Louvre

39. Bed in a Stable. Paris, collection of Robert Lebel

40. Blacksmith's Signboard
Paris, private collection

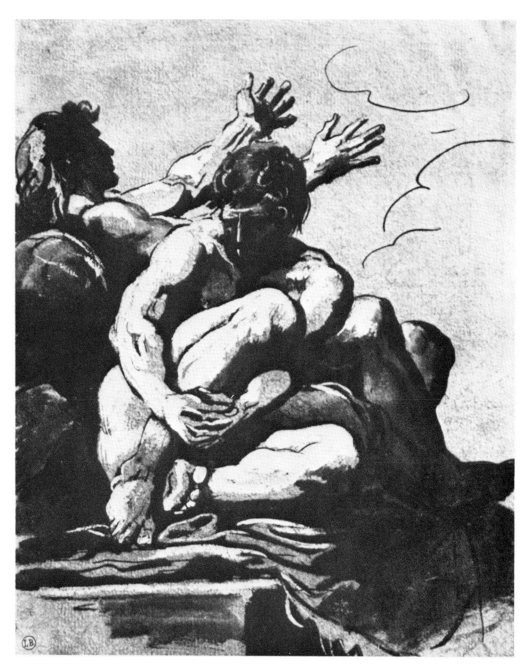

41. Rescue of the Shipwrecked (from the Medusa cycle)
Bayonne, Musée Bonnat

42. The Raft of the Medusa, first preparation. Paris, Louvre

43. The Raft of the Medusa, second preparation. Paris, Louvre

44. Detail from pl. 45

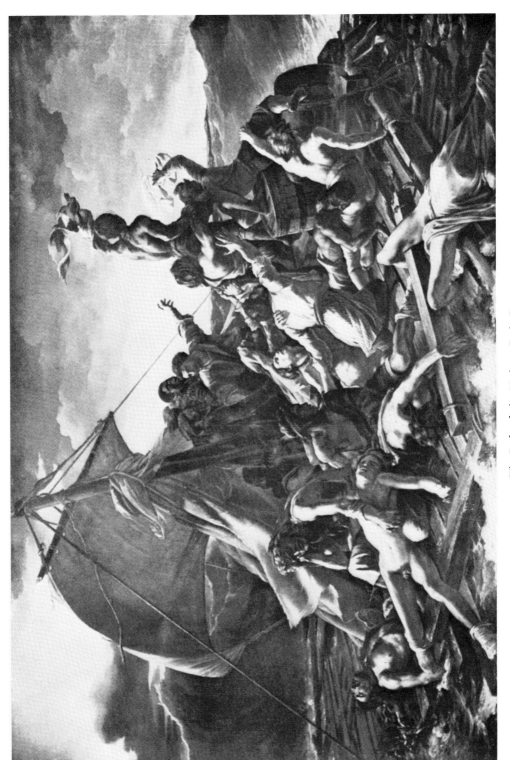

45. The Raft of the Medusa. Paris, Louvre

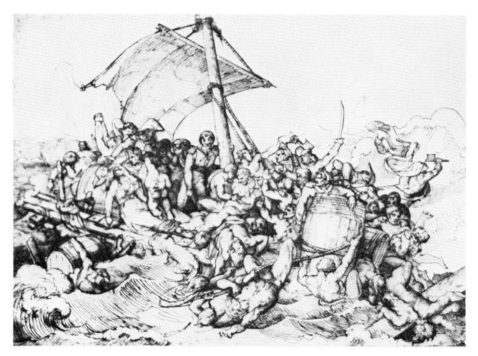

46. Mutiny on the Raft of the Medusa. Amsterdam, Gemeente Museum

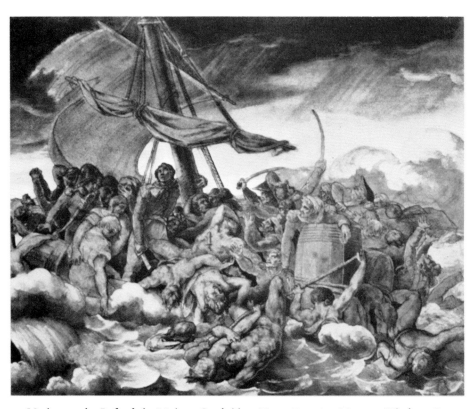

47. Mutiny on the Raft of the Medusa. Cambridge, Mass., Fogg Art Museum, Winthrop Bequest

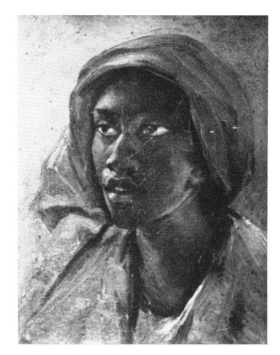

48. Negress. Bayonne, Musée Bonnat

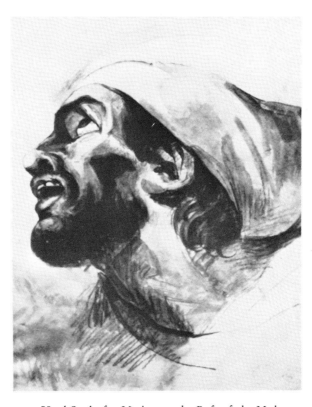

49. Head-Study for Mutiny on the Raft of the Medusa
Paris, collection of Maître Alphonse Bellier

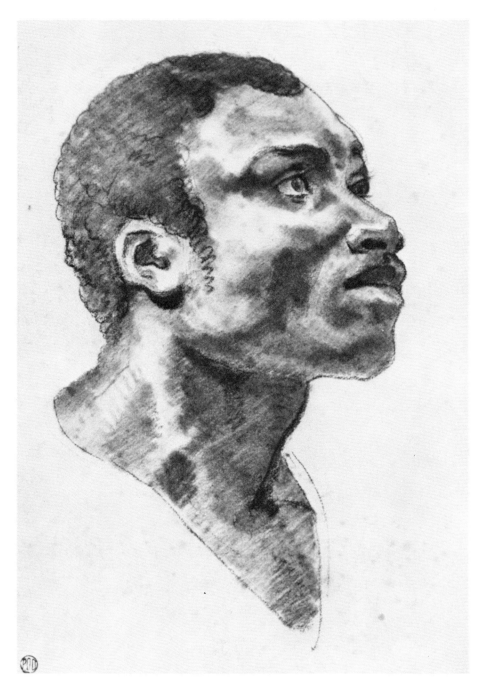

50. Head of a Negro
Paris, collection of Pierre Dubaut

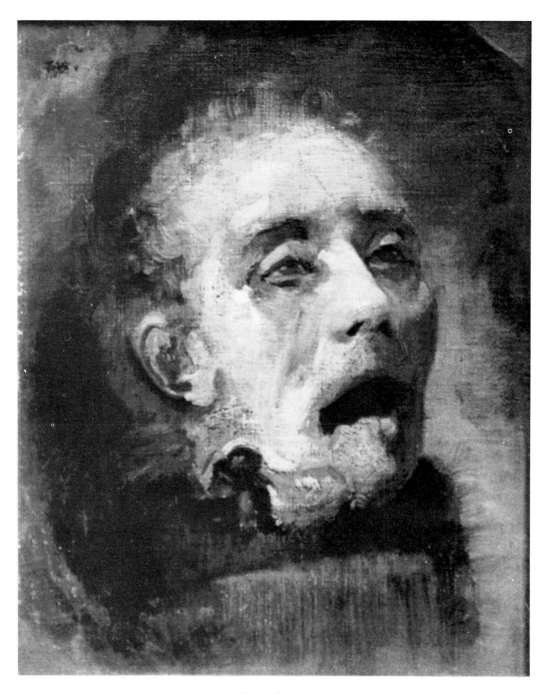

51. Head of a Corpse
Geneva, Musée d'Art et d'Histoire

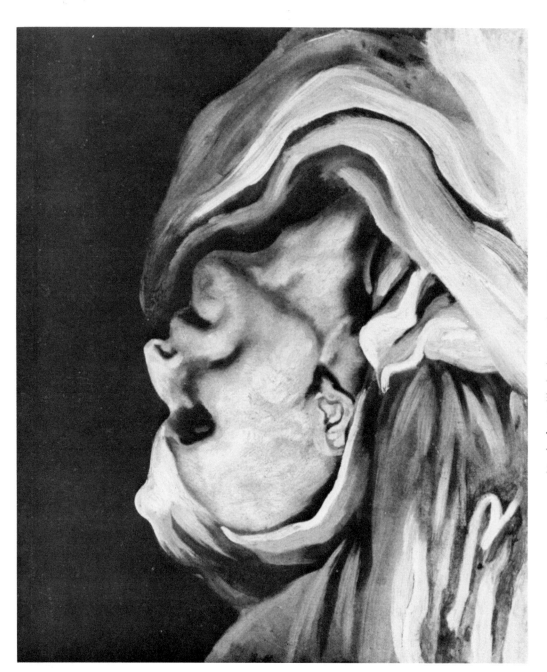

52. Head of a Guillotined Man. Chicago, The Art Institute

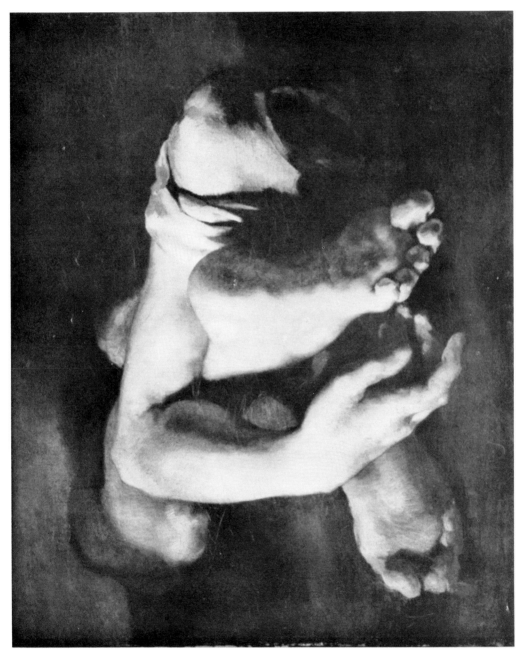

53. Still-Life with an Arm and Feet. Montpellier, Musée Fabre

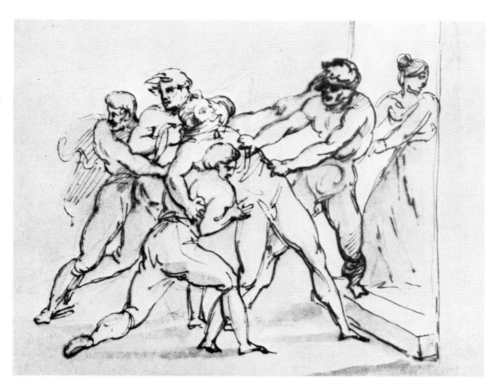

54. Fualdès Abducted into Bancal's Brothel. American private collection

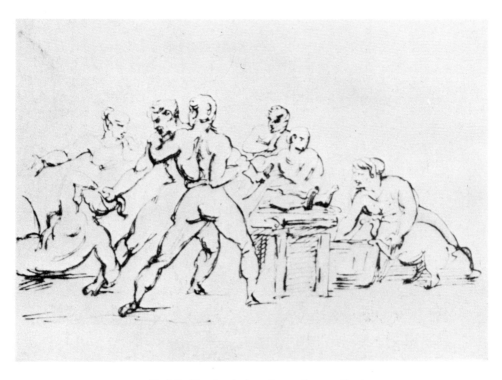

55. Fualdès Murdered. American private collection

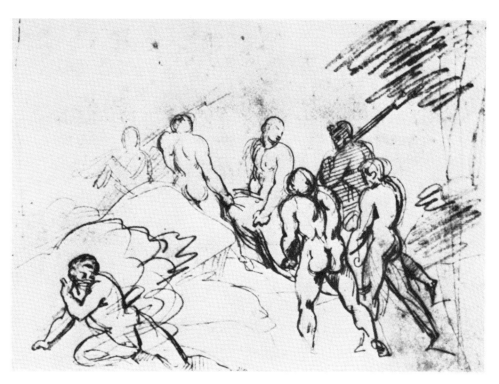

56. The Murderers Drag Fualdès' Body to the Aveyron by Night
American private collection

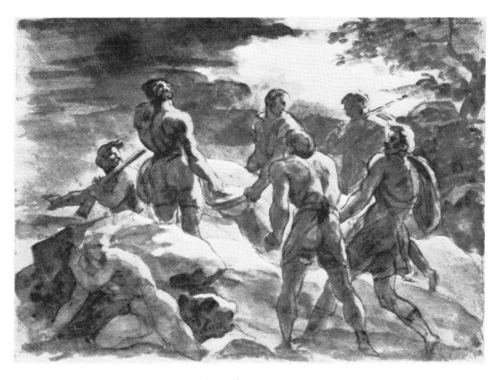

57. Variant of pl. 56. Lille, Musée

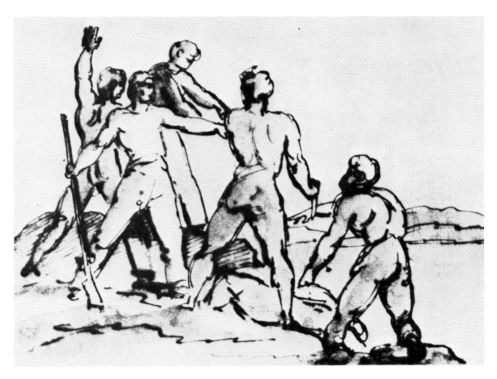

58. Fualdès' Body Thrown into the River. American private collection

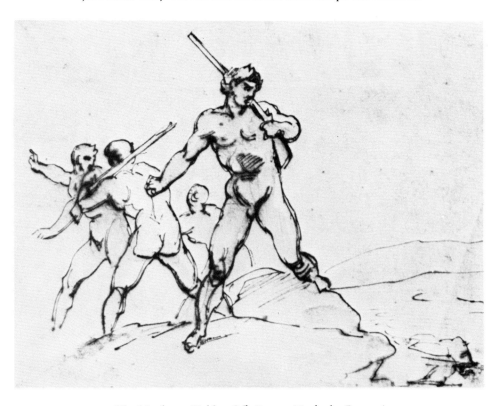

59. The Murderers Making Off. Rouen, Musée des Beaux-Arts

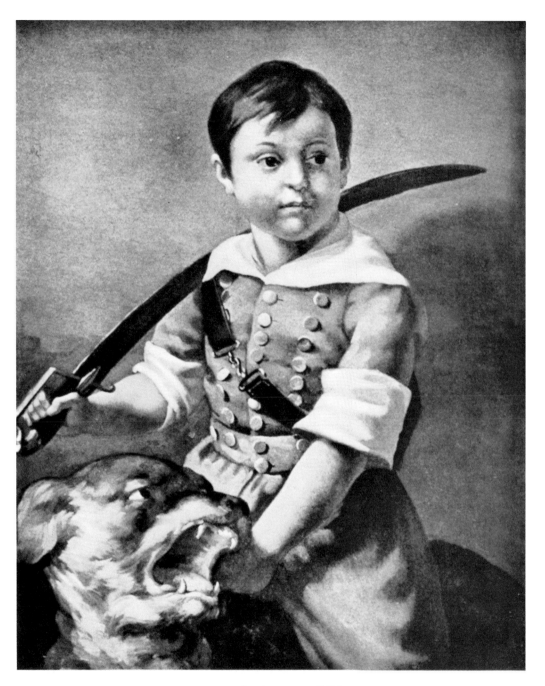

60. Colonel Bro as a Child
American private collection

61. Prize Fight. Lithograph

62. Mounted Artillery. Lithograph

63. Battle with Death. Berg am Irchel, Switzerland, collection of Hans E. Bühler

64. London Physiognomies. Paris, École des Beaux-Arts

65. Fishmonger (right half of the drawing)
Paris, collection of Pierre Dubaut

66. Horsewoman
Providence, Rhode Island, collection of Mrs. Murray Danforth

67. Pity the Sorrows of a Poor Old Man! (detail)
Lithograph

Le Supplice Gericault (Lh.)
 the N° 140, du Catalogue de M° Clement.

68. Hanging
Rouen, Musée des Beaux-Arts

69. Flemish Farrier. Lithograph

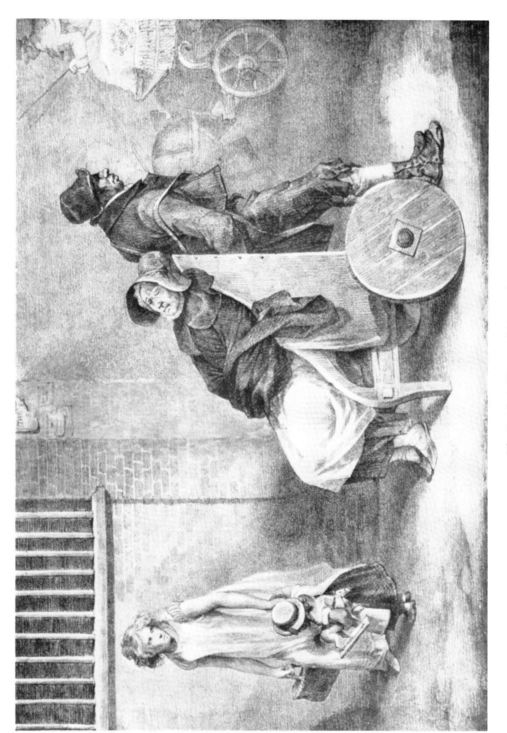

70. The Paralytic Woman. Lithograph

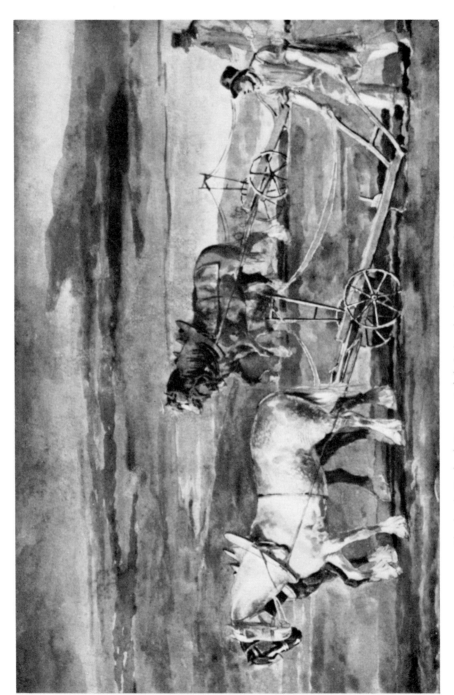

71. Plowing in England. Berg am Irchel, Switzerland, collection of Hans E. Bühler

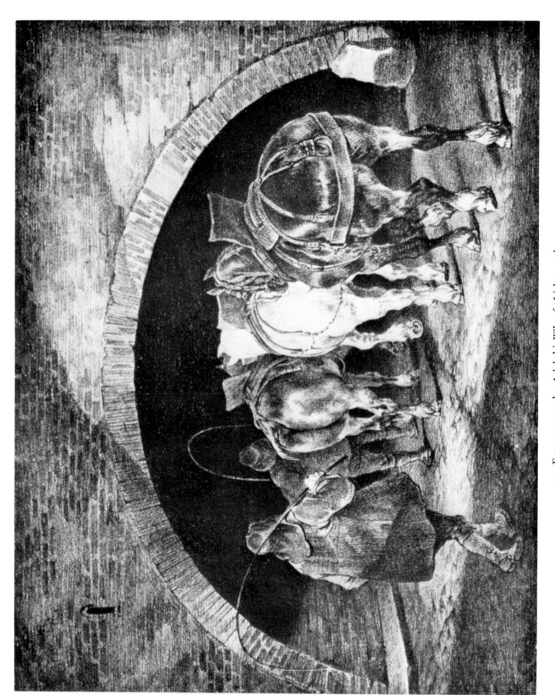

72. Entrance to the Adelphi Wharf. Lithograph

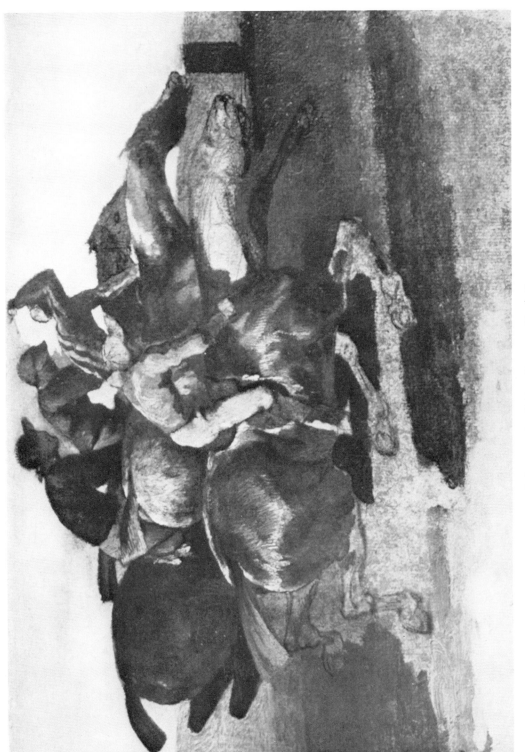

73. Jockeys at the Gallop. Bayonne, Musée Bonnat

74. Epsom Derby. Paris, Louvre

75. Coal Wagon with Five Horses. Basel, private collection

76. Coal Wagon with Seven Horses. Cambridge, Massachusetts, Fogg Art Museum, Winthrop Bequest

77. Wine-Barrel Cart. Providence, Museum of Art of the Rhode Island School of Design

78. Scene from the Greek War of Independence. Lucerne, art market

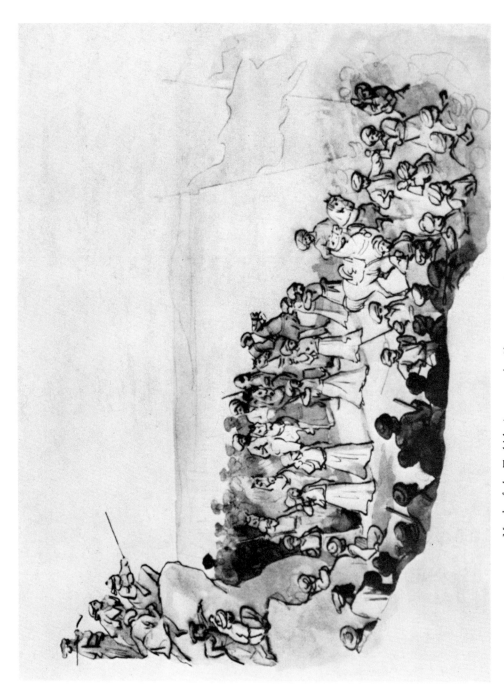

79. March of the Turkish Army on the Shore. Paris, collection of Robert Lebel

80. Madame Bro. Paris, collection of M. Bro de Comère

81. Louise Vernet as a Child
Paris, Louvre

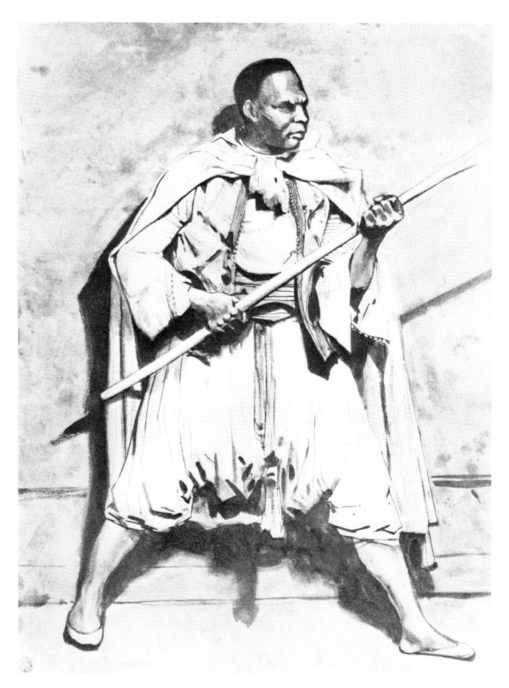

82. Negro Soldier with Lance
Cambridge, Massachusetts, Fogg Art Museum

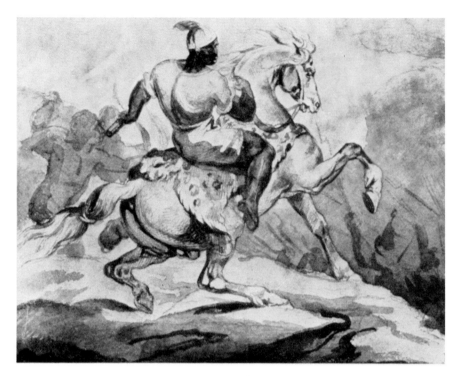

83. Negro on Horseback. Berg am Irchel, Switzerland, collection of Hans E. Bühler

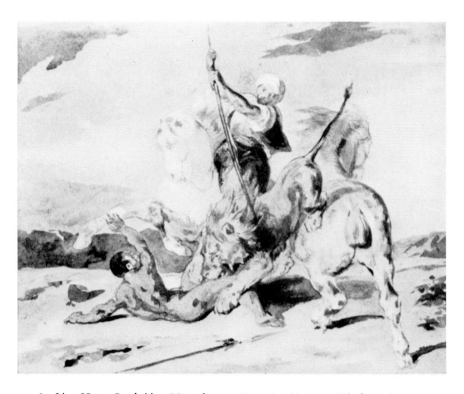

84. Lion Hunt. Cambridge, Massachusetts, Fogg Art Museum, Winthrop Bequest

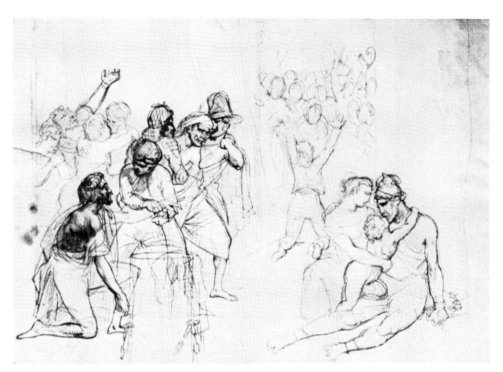

85. Liberation of Victims of the Inquisition. Paris, collection of Pierre Dubaut

86. The Slave Trade. Bayonne, Musée Bonnat

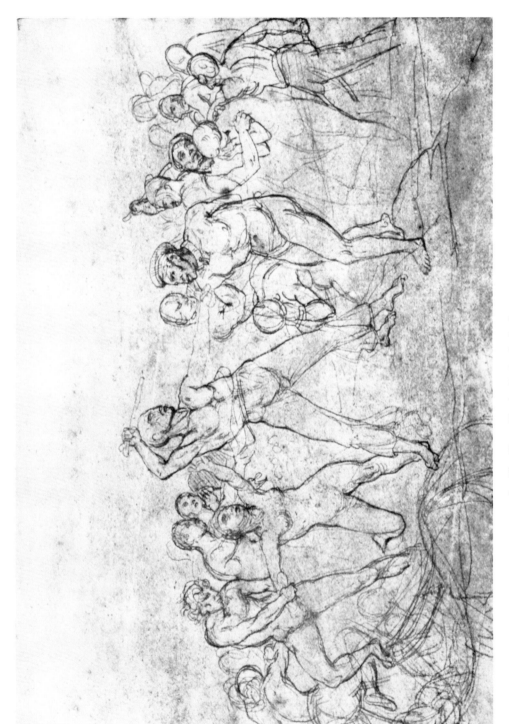

87. The Slave Trade. Paris, École des Beaux-Arts

88. Landscape with a Limekiln. Paris, Louvre

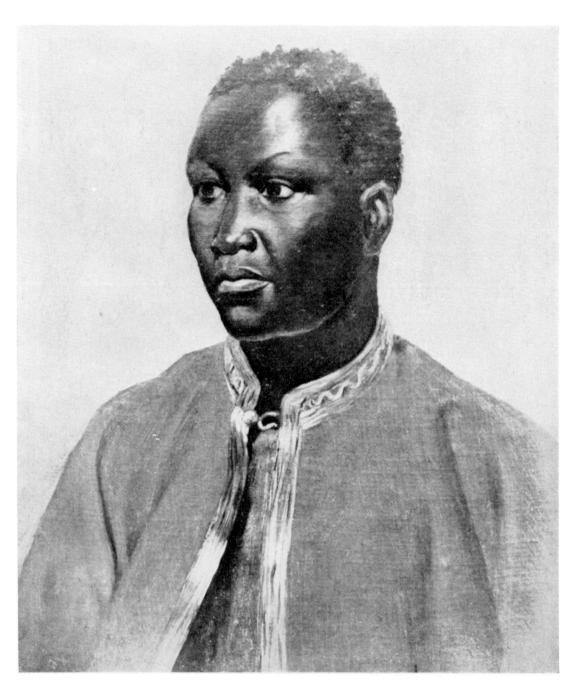

89. Negro
Buffalo, New York, Albright Art Gallery

90. Man from the Vendée
Paris, Louvre

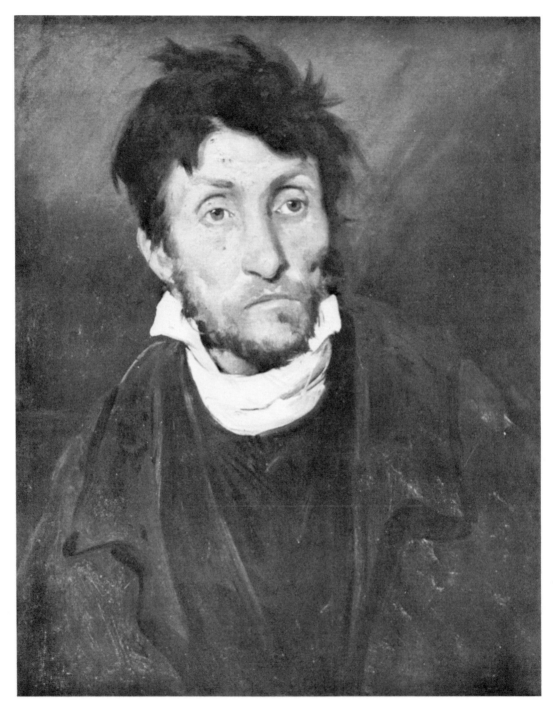

91. Kleptomaniac
Ghent, Musée

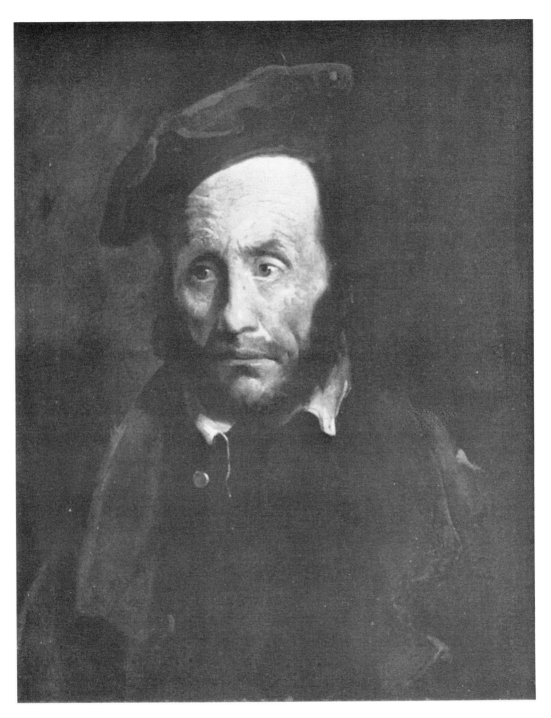

92. Insane Kidnapper
Springfield, Massachusetts, Museum of Fine Arts

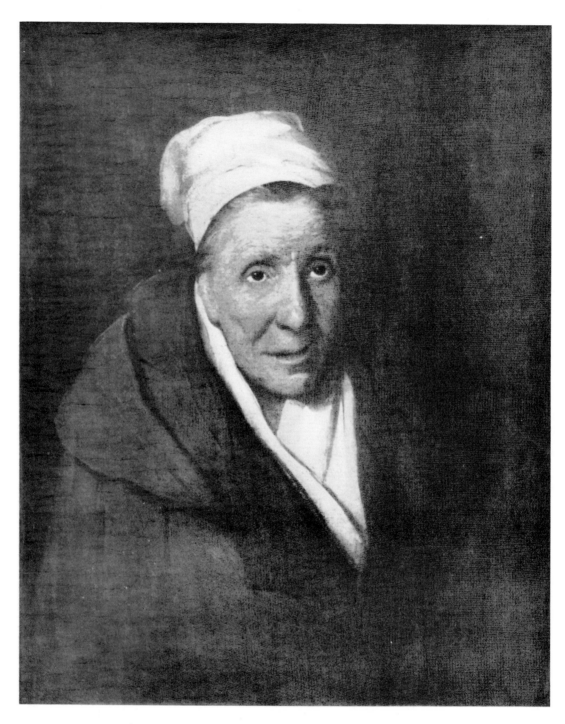

93. Insane Woman (Malicious Mischief)
Paris, Louvre

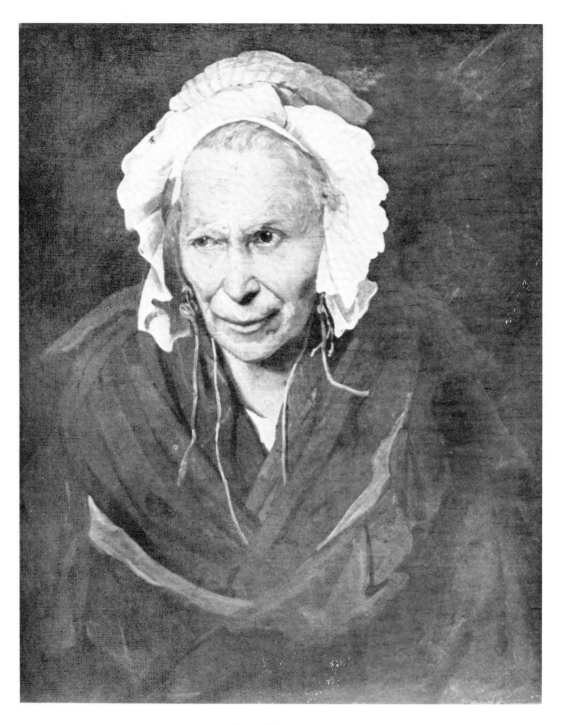

94. Insane Woman (Envy)
Lyon, Musée

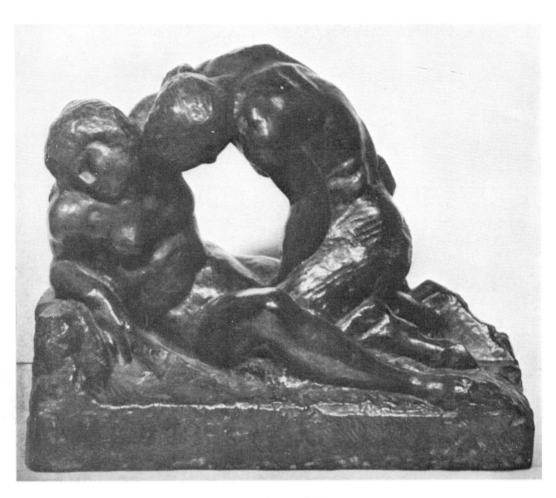

95. Satyr and Nymph. Bronze
Paris, collection of L. Rollin